Glue and Ink

Rebellion

by

Sean Carswell

Amy,

Thanks for coming back for this book.

GORSKY PRESS
COCOA BEACH FLORIDA
2002

Glue and Ink Rebellion

copyright © Sean Carswell, 2002

"Fifteen Bucks and a Cookie", "Brandon's Posse", and "Nowhere, Alabama" were previously published in *Razorcake*. "I've Got a Bad Feeling about This" was previously published in *Clamor*. "Waiting for Thor" and "Beauty Smacking Me Upside the Head" were previously published in *Ink 19*. "Saturday Night at the Harbor" and "Fiction of Old Friends" were previously published in *Talk Story*. "Bulldog Front" was previously published in *Thin Air*. All stories have been revised since their original publication.

Special thanks to Felizon Vidad for coming up with the concept for the cover, for editing all of the stories, and for everything else.

The sketches used in the cover collage and all interior artwork was created by Tom Wrenn

Cover design by Sean Carswell

ISBN 0-966-818547

gorsky press

P.O. Box 320504
Cocoa Beach, FL 32932
www.gorskypress.com

Printed in the United States by
Morris Publishing
3212 East Highway 30
Kearney, NE 68847
1-800-650-7888

Author's Dedication:

A few chapters in my first novel and many of my early writings were based on my brother's stories. I heard him tell the stories again and again, and, eventually, I stole them. It only seems right that I give him credit for that somewhere, so this book is dedicated to my brother, Scott Carswell.

Also by Sean Carswell:

Drinks for the Little Guy

Table of Contents

Nelson Algren and Me: a Preface

People often tell me that I'm wasting my time and wasting my talents. They ask me why I only write for zines and small publications that generally don't pay me. They point out that I live in a ghetto (though I don't think it's a ghetto) and that I have no money and that I should really grow up. I seem to be a magnet for people who want to ask me, "Why don't you just write (<u>fill in the blank</u>) and make some real money, then worry about writing what you want?" My answer is always the same. I've told it many times, but here's the "motherfucker" story.

For a long time, I wrote only fiction. I don't know if I was an elitist or lazy or what, but I never tried to write anything except short stories. I'd occasionally send these stories off to literary journals, and I'd occasionally have success in the sense that a journal would publish the story. I'd also read my stories to crowds at bookstores or bars or basements. At these readings, I noticed that I was different from my contemporaries. Whereas the poets I'd perform with would sit on a stool and read pleasant, thoughtful poems, I'd often pace back and forth, telling stories and cracking jokes and yelling and screaming. I liked to think that I was like a punk rock singer, only without the band. One woman who saw me read told me that watching me was like watching the caged lion at a circus. Other people said I looked like a drunken asshole, too, but I'm trying to focus on the positive, here.

I performed a reading at a college one night in April of 1996. That night changed the way I looked at writing.

It was a "symposium." The other writers brought water up to the podium and told their stories or read their poems in a nice, civilized manner. I was nervous watching them because I knew I'd be too nervous to stand at a podium and read into a microphone. When my turn came, I tried to see if the microphone would come off the podium so that I could wander around with it. It wouldn't budge, so I decided to forego the mike and scream out my story across the lecture hall. The story was called "Bulldog Front." The title is a reference to a Fugazi

song, and the story is about five drunks who live together in a house and settle all of their disagreements by boxing each other. It's not a nice, civilized story. Sure, someone could study it for a literary criticism class, and they could argue that it's largely a metaphor for the escalation of arms and the downfall of a military mindset, but no one ever will.

I screamed through the story. The audience gave me a nice, civilized round of applause. I figured that the applause was their way of heckling me. Strangely enough, though, after the symposium, two editors of a literary journal asked me if my story had ever been published. I told them that it hadn't. They asked me if they could publish it in their journal. I said that they could, and I handed them the copy of the story that I'd just read.

Two days later, one of the editors called me up and said something like, "I've been looking at your story and I really like it, but do you realize that you say 'motherfucker' five times in the story?"

"I didn't count my motherfuckers," I said.

"Well, there's five of them," he said. "Now I think we could get away with maybe two motherfuckers, but five is too many. Would you mind cutting three motherfuckers out for us?"

I thought about it and decided that I would mind. I didn't really know how many times I'd put that word in there, but I did know that I was trying to give a realistic portrayal of working class life. I was trying to give an idea of the humor and desperation and boredom and futility and good times that working men experience. I wanted to write about the world I lived in and the people I knew. I felt like, if I betrayed the language of my culture, then I betrayed my culture. I wasn't willing to do that, so I asked the editor to just send my story back to me and forget the whole thing.

I also understand the editor's point of view. He knew his audience. He knew what they'd tolerate and what would offend them. I can't blame him for not wanting to offend his readers. That's fine.

Around the time of the motherfucker incident, I'd also written another story. It was about a guy who wakes up after drinking way too much, and he can't find his truck. I'd written that story because, well, to be honest, I've spent more time than I want to admit wandering around town, looking for my own truck. A lot of my friends have spent a lot of time in the same predicament. I thought about this story and thought about counting the motherfuckers, so to speak. I realized that this (as a real portrayal, not as some silly teen B-movie) would also likely offend the symposium and lit journal audience. At the very least, that audience

wouldn't be able to relate to my story. Then I thought of all of my stories and realized that they were all about drunks, potheads, punk rockers, bartenders, waitresses, drug fiends, commies, surfers, skaters, and various working class dregs. I realized that I just wasn't a nice, civilized writer. If I wanted anything more out of writing than to simply get published, I had to look for my audience.

It wasn't a difficult search. I did what should've been obvious to me from the beginning: I started writing for the publications that I read. I started doing record reviews for *Flipside*, a Los Angeles-based punk rock magazine. Gradually, this led to interviews with bands, articles, and a bi-monthly column. I also contacted a local Florida music magazine, *Ink 19*, and did semi-regular columns for them. When I felt political, I sent articles to one of my favorite political magazines, *Clamor*. I put out zines of my own short stories and short stories of other writers. I published my first novel, *Drinks for the Little Guy*. I even wrote for larger publications like *Thrasher* and *Fat Free Radio* sometimes. Mostly, though, I stuck with zines.

Then, something really cool happened. I found out that people were actually reading what I wrote, and they were responding to me. Sure, I got some negative responses. The typical you're-a-drunken-asshole stuff. Fair enough. But I also heard from a lot of people who actually sought out my columns and stories and bought magazines just because I'd written something for that issue. It blew me away. It made me realize what I'd always wanted out of writing: an acknowledgement, a response, a conversation based upon honest, sincere ideas.

So I still don't blame that long ago editor who could only abide two motherfuckers. I don't have anything bad to say about traditional literary journals and traditional paths that writers take. It's just that I love zines. I love people who feel comfortable examining their culture and using the language of their culture and not worrying too much about offending their audience. I love people who get lightheaded off of rubber cement while they cut and paste their ideas together. I love magazines that are born out of a copy shop and put together by people who have learned how to avoid paying for the copies. I love reading newsprint fanzines with erratic publishing schedules and with pages that leave my hands ink-stained. I love zines because they give an honest insight into human emotions and behaviors. I love them because I can read a cool story and contact the writer and talk more about the story. I love zines because they encourage the participation of ideas and

action. I love the whole zine culture. It's a glue and ink rebellion.

The only downfall, though, is that my writings seem to reach a very small audience and go away quickly. When I look back at some of the things I've written, believe me, this has its advantages. But there were also a bunch of out-of-print stories, columns, and articles that I was really proud of. For a long time, I wished that people could still read some of them, but I didn't know what to do about that.

Then, one summer day in 2001, I was hanging out in the Cocoa Beach library, trying to cop some free air conditioning, when I stumbled across Nelson Algren's *The Last Carousel*. I read through it and noticed that Algren ignored the idea that books should either be all fiction or all non-fiction. Algren seemed to have no regard for the line between the two. He told a story and let you decide what was true and what wasn't. I was blown away. How could Algren be so cruel to his readers, who wanted solid, definable lines between fiction and non-fiction? How could he be so cruel to the noble bookstore employee who held *The Last Carousel* in his hand and stood between two aisles, not knowing which shelf to put it on?

I also related to Algren because his stories, like mine, were all about working class dregs. I got the sense that he and I both lied a lot when writing non-fiction and told a lot of truth when writing fiction. I decided to follow in his footsteps. Perhaps in hopes of a whole new bookstore shelf that's just Nelson Algren and me, I went through everything I'd written over the course of six or seven years and selected my favorite stories, fiction and otherwise. I revised all of the stories and collected them in this book. Hopefully, this motherfucker will serve as a nod to the largely ignored working class culture and to the whole zine rebellion.

Springtime Tallahassee Noon

Springtime Tallahassee Noon

My world spins around me; my reality rolls. Like a wave. Sometimes I catch it. Stand on top and look down at the face and feel my feet solid on the wax, push down on my left foot and drop in, ride it for all it's worth. Sometimes I sit on my ass, looking out to the east, waiting for the next set to come in. Watch the first of it ride by. Never take the first wave of a set. Wait for the second, at least. If you're really bold, hold out for the third. Sometimes I wait and paddle like hell because I know that if I don't catch it, it's gone. Sometimes I don't even try. I watch it come in and go out with the tide. Watch for sets of reality, one rolling in after another, crashing in the sand, dying there. A new set. Sometimes reality is six foot and glassy. Sometimes it's slapping my ankles, and I realize that I'm way too old to be standing on this shit. Usually I don't care. If reality's a wave, I know that I'm nowhere near the ocean and can't surf worth a shit anyway.

Anyway, I lie in bed most mornings trying to separate dreams from reality. Or I try to separate waking reality from sleeping reality, or waking dreams from sleeping dreams, or just wonder how I made it into that bed the night before and how I'll make it back into that bed again once I get up. And I'd had a hard night that night. I'd trashed my truck, gotten busted, and gotten laid. Or any one of the three. Or none. I couldn't be sure. What I was sure of, though, was that I was about to puke at any second. I figured that, if I just lay real still, that too, like a wave, would pass.

The big curiosity was my truck, because one thing I know is that I'm a damn good driver. I never even have close calls. But I could close my eyes and see it skipping the curb and flying clear up into someone's front porch. And I could see the porch, red brick, white cement steps leading up to it, a hammock dangling from two columns. I knew the porch. It was about a half mile down the road, on the one way street that ran in front of my house. That's why it didn't make sense. Why would I be driving home on the one way street that went away from my house? And how did I get home? I closed my eyes and tried to think,

but remembering anything is like a dream some mornings: if you try too hard, it vanishes forever.

Lying in bed wasn't the best bet, either. If I'm alone for too long, all grip is lost. Maybe it's my imagination. Maybe I'm never totally awake. Maybe that's why prisons have solitary confinement. Whatever. I just wanted something to tell me that I was awake. That's when I heard my roommate walk into the kitchen, singing like he always does, rock and roll tunes like he's a lounge act, "*Been caught stealing, hey, when I was five, yeah.* Thank you very much. Anyone here from Reno?" With all I didn't know and didn't understand, I knew I had to stop him. I braved the churning of stomach acids and rotgut, pulled on a pair of shorts, and walked into the kitchen. One door of my bedroom opened into the kitchen. I was face to face with Norm just as he started his rendition of "Suburban Home."

Our cat, Mr. Blonde, had taken a bite of Norm's lip when Norm was holding him a couple of days ago, so Norm had a gash running from the right corner of his mouth, about a quarter of an inch long. Black stitches ran out of it. "What's up, Tommy?" he asked me.

"What I want to know is," I said, "does your lip hurt worse than I look?"

Norm touched his fingers to his stitches, looked me up and down and said, "Not even close."

I took this as an invitation to his codeine sitting in a prescription bottle in the spice rack. I popped one and washed it down with a Coke from the refrigerator. I looked around the place for a clock. As if I didn't live there. As if those weren't my dishes growing mold in the sink. As if somehow a clock had magically appeared overnight. Since one hadn't, I checked the clock in Norm's room, on the other side of the kitchen. Eleven. Damn. Just woke up and I was late already. Like that first set of waves rolled in right under my board.

I cut back into the kitchen, then into the bathroom. The house had a fucked up floor plan. It was a long rectangle. The front door led into a living room. Beyond that was a long hallway. Two bedrooms sat along the right side of the hallway. The roommate who was never home lived in the first room. Norm lived in the second. The bathroom was at the end of the hall. To get into the kitchen, you had to cut through Norm's room or through the bathroom. My room was on the other side of the kitchen, and I had a door that led out into our driveway. Anyway, I stood there, one hand against the wall to prop me up, taking a leak, thinking about puking but feeling like I could ride it out. I washed my

hands and face and brushed my teeth with my finger because I was afraid that toothpaste would push me over the edge. Then, I headed out. Through the kitchen and my room and out the door to the driveway. But my truck was gone. Damn. Reality fucking with me again, and me thinking, maybe I really did drive up on that porch the night before. I went back into the kitchen and asked Norm if he'd seen my truck.

"Of course I've seen your truck," he said. But not like a smart ass. Like he was clueless. So I didn't get mad. In fact, that's what I liked about Norm. He was always so slow from drinking so much that he had an innocence about him, like a child in a forties Christmas movie.

I said, "No, man, I mean have you seen it today?"

Norm looked out the kitchen window, across the driveway. He took a good thirty seconds to make sure, then said, "Nope."

"Fuck," I said. Then I looked down at myself and realized that I still had only a pair of shorts on and had forgotten to fill the pockets. I went back into my room, put on a t-shirt and slid into my Adidas sandals, unlocked the box above my bed and pulled out four quarter bags already measured out, and stuck them in my pocket. Then I took to my feet.

The house I was walking towards was the same house that I was thinking I'd crashed my truck into. That was another reason for thinking that my truck was safe—because, from what I know about dreams, they tend to mesh with what is on your conscious mind. And if I were thinking about my truck and my delivery at the same time just before I hit REM, well, that would explain the accident.

The codeine was settling into my nerves nicely, and the pain in my head was still there, but no longer threatening and omnipresent. The Tallahassee morning fell down gently around me. I started to sweat, more from the booze, I think, than from the soft heat. And the walk was a nice one, through the streets lined with oaks, camphor trees, and pecan trees. I stopped to pick up a handful of pecans from my neighbor's yard, stuck them in my empty pocket, then picked up another handful. If you hold two pecans in one hand and squeeze, you can crack one of the pecans and pick the nut out of the shell. When you get down to your last pecan, though, you need a nutcracker. That's why you always want to pick up one more nut than you plan to eat.

I walked along in the shades and the greens of West Pensacola Street, eating my pecans, feeling peace with the sidewalk like it was the ocean under my board. When I got close enough to the house, I could see that no damage had been done to the porch. But that didn't mean

Glue and Ink Rebellion

much. I had an aluminum can of a truck. I'd seen models like it crushed down to the frame going no more than twenty miles an hour. I walked up closer to the spot where I'd remembered hitting the porch and didn't see any paint on the bricks. I sighed. Fucking cool, man. My truck was fine. Just a matter of finding it. I climbed the cement steps and walked through the front door. I wasn't the kind of delivery man who knocked.

The whole crew was sprawled out about the place. Five guys sitting around. Only the long-haired one in the recliner, Joel, lived there. I knew all but one of the guys. The place was dark. All the shades were drawn; no lights were on, nothing to let you know what a blue day it was outside. I scratched my head and didn't take a seat and said, "What's up, fellas?"

"You got some bootlegs?" Joel asked.

I shook my head and looked at the one guy I didn't know. I offered him my hand and said, "I don't think we've met. I'm Tommy."

"Yeah," the dude said. "We met last night. At Andrea's."

"I don't know any Andrea," I said.

"You damn sure did last night," the dude said. Everyone else in the room laughed as if they'd just been talking about me and whatever it was they thought I'd done with Andrea. Or as if they hadn't and I was being paranoid, which was even worse. I don't like being paranoid. It suggests a breach from reality in a way that I'm not cool with at all.

So I came right out with it. I asked, "Are you a cop, man?"

"Yeah," the dude said. "I'm a cop."

"That's not the answer I'm looking for," I said. "I'll ask you again. Are you a cop?"

The dude looked around the room with a cocky smile on his mouth and said, "What is this? Are you serious?"

"No, man. I'm not," I said. "Look, I gotta split. Sorry, Joel. I got no bootlegs today. I got nothing but a hangover. I'll call you later." I started for the door slowly, feeling myself drop in on an overhead wave of paranoia. I felt like someone was going to kick the door in at any second, some militant fuck in black and a bulletproof vest carrying an automatic weapon, with a whole crew of sick fucks just like himself behind him, all fighting some war that I just didn't want to be a part of. Or maybe outside would just be that sunny spring day that I'd left there. Either way, it was time for me to find out. I did pause at the door, though, to ask if anyone had seen my truck. The annoying dude said that I'd probably left it at Andrea's. "Man," I said. "I don't know any Andrea."

The walk home wasn't nearly as nice as the walk there, although I did at least have the peace of mind of having reason to believe that my truck wasn't trashed. But I'd planned on making two hundred bucks off that walk, off of four dudes I knew and trusted. But that one smart ass. All he had to say was, "No. I'm not a cop." But he had to be a fucking comedian, and then I didn't know what to think because maybe I was paranoid and maybe I did overreact and maybe it's not really entrapment if the cop denies he's a cop, even if someone else is wearing a bug and it's documented. And I really should've read up on the laws because it was my business and I was selling the shit small time to get by. And maybe I was wrong, but I thought that if it felt wrong, I may as well leave it alone. I was unloading a couple of pounds of grass a month and I could trust most of my buyers, the nouveau hippie college students with their rich ass parents down in Miami, funding me with the extra cash they're parents sent them every week. So an ounce didn't hurt me, but it brought back the second pain from the night before. Because I really didn't know if I'd gotten busted or not. That my truck hadn't run into the porch lessened that threat, but that fucking dude, man. Talking all that shit. If he wasn't a cop, then why was he such an asshole? I walked up my porch and in the front door, through the front room, down the hall past my roommates bedrooms, through the bathroom, and into the kitchen.

Norm had just finished his scrambled eggs and piled his plate on top of the dishes that were coming closer and closer to life in the sink. "What do you have on for today?" I asked him.

"Working later," he said. Then, he turned his head, looked to the ground, and said, "Wait. No, I'm not."

I picked up the bottle of codeine from the spice rack and popped another one. The first one was feeling so good that a second one couldn't hurt. "You use any of these yet?" I asked.

"My mouth doesn't hurt that bad," he said.

"Trade you an eighth for the bottle."

"I'll get that refilled if you give me a quarter," he said. I pulled a quarter ounce of weed from my pocket and tossed it to him. He immediately started packing the little pipe that we kept in a jar with the sugar. I didn't mind giving the grass to Norm because I figured he stole it from me anyway. And I only figured that because I was always stealing his booze. He worked at the liquor store at Albertson's and brought home a bottle every night. I didn't pay for cocktails unless I went to a bar. When he was around, he offered his booze to me, but if

he wasn't, I just took it. He had to know that he wasn't drinking a fifth a night just like I knew I wasn't smoking a half-ounce a week. I also knew what move Norm would make next, and sure enough, by the time I'd gone back into my room, stashed two of the three remaining quarter bags, and got back out to the kitchen, he offered me the pipe. That was the reality of Norm. I could know that. I could know Norm's reality better than I could know that, if I lifted my leg to take a step, the ground would catch it when I went to put it down. Norm was more consistent than my footsteps. He didn't stumble. Always made the same move.

We smoked a couple of bowls, then I asked Norm if he'd drive me to my truck. He asked me where it was. "I don't know," I said. "I thought we could just drive around." Norm laughed at me. "No," I said. "I mean retrace my steps until I can remember where I ended up last night."

"What's the last place you remember being at?" he asked.

I shook my head. Then, I got an idea. I checked my back pocket. I could feel my driver's license. I checked the front pockets. A bag of weed in one and a lonely pecan in the other. I pulled out my driver's license and a scrap of paper fell out. In fat, round handwriting it said "Andrea" and "576-0434." Norm picked it up and handed it to me. "Do you know anyone named Andrea?" I asked. He shook his head. "Well, we were at the Blind Pig for a while, weren't we?"

"Yeah," Norm said. "Maybe you left it there." He picked up his car keys, and we headed through my room, out to the driveway. Just before we pulled out of the driveway, I said, "Hey man, I didn't call you to bail me out last night, did I?"

"No," he said. The southbound lane emptied out and Norm pulled across it, heading north. He didn't ask me if I'd gotten arrested. Just said no.

I liked driving with Norm. It brought me close to death. He drove around Tennessee Street like it was the Daytona Speedway. Everyone else drove Tennessee Street like it was a scenic route. It reminded me of that old video game Pole Position—weaving in and out of cars like they were cones, just looking out for that inevitable oil slick up ahead, hoping not to spin out into an Atari billboard. And I liked being stoned, with nothing to do but find my truck, on a springtime Tallahassee noon.

We pulled into the Blind Pig parking lot and my truck wasn't there. We decided to duck in and grab a beer, anyway.

The Blind Pig was a barfly bar. Some college kids would go there at night, but at noontime on that Wednesday, the only people on the

stools would be out on the streets that night, begging for change and were probably in the plasma clinic earlier that day, selling blood. The only other people in the bar were a drywall crew shooting pool on their lunch break. I knew these guys and, if the past was any indication of the future, they wouldn't end that lunch break until the next morning. I knew that because I used to work with them. We'd all gotten fired, one by one, but they'd all gotten hired back. I still had another month, probably, before the boss would fire one of them and call me. Herzog, the man who finished the drywall, who made the most money on the crew and turned a lot of that money over to me for dope, sat on a stool in the middle of the floor. His back was to the door and he was watching the two drywall hangers play pool. He was a fat guy with a crew cut, wearing white painter's overalls. I tapped him on the shoulder.

"Hey, Tommy," he said with a big, fat smile. "Just the man I wanted to see. You got God in your pocket?"

"God costs fifty bucks today," I said. He nodded and we did the handshake exchange. So then I had fifty dollars to drink on. Norm bought a pitcher of Bud. Bud was all they kept on tap there. We stood around drinking for a while, telling construction stories, bitching about the Man and the hours and all that shit, and man, I was glad again. This time I was glad that I didn't make my living that way anymore. Throwing up four by twelve foot sheets of rock for fifty cents a board. Fuck that. I saw myself as more of a clerk than anything. Just like Norm, only I didn't stand in front of my stock, wondering if someone was going to pull a gun on me. Instead, I walked around with my stock, wondering if someone was going to pull a gun on me. We both sold what people got arrested for having at the wrong time, what people ingested, and whether it was a good time or a bad time, it was a time. But I liked to hear the construction stories because, even when they weren't funny, they reminded me of something similar that was funny. And because I knew I'd be doing that shit again.

After a while, Herzog looked at his watch and said he had to go. "You're not going back to work, are you?" I asked.

"Hell, no," he said. "Going to the Shack. Happy Hour."

"All right," I said, slapping him five. "I'll probably see you there when we get done with this pitcher." The three of them started out the door. Then, I remembered and said to Herzog, "Hey man, have you seen my truck?"

"Yeah," Herzog said in a low grumble. "Little rice burner piece of

shit." Then he was gone. I got two dollars worth of quarters, and Norm and I shot pool until the beer ran dry.

As we walked out, the bartender was asking a woman to leave: a short, Asian woman who just stared at the bartender like she didn't understand a word. Norm was about five feet in front of me and, as we left, the Asian woman fell in line between us. The sunshine came down pretty hard once we left that cave of a bar. The woman looked to me to be Vietnamese and mumbled something in that language. Or at least I thought she did, and I thought it was Vietnamese although I only thought that because it didn't sound like how they talked in *M*A*S*H* or the *Godzilla* movies, and I had a Chinese chemistry teacher in high school and he didn't mumble like that, and I guess it could've been Lao or something. It doesn't matter. I was thinking about letting that wave pass when she turned to me and said, "Oh, was I just talking to myself?"

I shrugged. The language change was too much and I hadn't been expecting her to talk to me in any language.

"I'm sorry," she said. "I just went in there to see my babies."

"Who?" I asked.

"My babies. They hang on the walls in there. My babies."

"Your babies?"

"Yes. Babies. On the walls."

And she said it so convincingly that I decided she must've believed what she was saying, just used the wrong word. We got into the car and Norm pulled out of the parking lot. I wondered what else hung on the walls that she could've meant and thought maybe it was the paintings. That would've even made the word "babies" make sense. But I never could remember any paintings on the walls. I figured that I must've just imagined it all. Not hallucinated. I've hallucinated. It's much different. Imagined.

Then Norm said, "Her babies hanging on the walls? That woman must've been nuts." And I felt relieved.

Norm gave me a ride back home and told me that he'd forgotten, but he was supposed to pick up his girlfriend from class. If I would've been thinking, I could've reminded him of that. He stopped at the traffic light on the corner in front of our house. I hopped out and headed west down West Pensacola Street to the bus stop.

The bus stop was on the southeastern edge of the university, just outside of the perimeter of where the students tend to get on. So I was

waiting exactly where I wanted to be: outside of the students. Not that I have anything against college students. I couldn't make my living without them. I just try to avoid conversations with them most of the time because the conversations tend to have a predictability. But not that nice kind of predictability. Not like Norm. Because when Norm packs a bowl after breakfast or drives Pole Position across town, he does it naturally. Like it's the only thing to do. That's why I like it. Like it's offshore, a set of three rolling in whether I'm waiting for it or not.

The bus came and I rode it to Doak Campbell Stadium. Then I cut through the parking lot of the stadium, across the abandoned railroad tracks, through an empty lot, and up to the front door of the Shack: the best bar in Tallahassee until eight o'clock. After eight, anything could happen at the Shack. Any kind of crowd could show up. Shitkickers one night, bikers the next, a sorority social the next. Before eight, though, it was all locals like me. When I walked in, there was only one local and that was me. No one else in the bar but the bartender. I pulled up a stool and she poured me a draft without asking me what I wanted.

I liked this bartender and, in fact, I think I have a woman bartender/waitress fetish. No women turn me on like the ones who control the beer. It may be something simple and stupid, like they tend to have nice legs from all that walking around. Maybe it's Freudian, going back to the whole mother's milk thing. Maybe it's because our careers are so closely related. Or maybe it's just that the waitresses and women bartenders tend to be attractive in this town. Whatever. I dug this one, dug her throaty, smoker's voice when she laughed, and dug her short brown curly hair and sunken cheeks and the way her lips made me want to kiss them one at a time. I didn't know her name, but I'd been around enough and seen her out enough to know her. She knew me well enough to know what I was drinking before I ordered.

She set my beer on a coaster in front of me, leaned on her elbows on the bar, looked at me kind of weird, like she knew something I didn't, and said, "Have a good time last night?"

From the way she said it, I thought something might be up, but maybe not, so I said, like I could've been kidding or could have been clever, "Yeah, you know, I dreamed I got in a car wreck, got busted, and got laid, and I can't figure out which of the three wasn't a dream. But I can't find my truck, had a run in with the law already today, and I really like the way you're looking at me."

She laughed and it seemed to me that she laughed like she thought I was being clever, but I can't really judge laughs all that well. So I

asked her if she had a good night. She bit her lip and moaned and nodded her head, and I thought, what the fuck does that mean? I knew it meant that she'd probably gotten laid, but the way she looked at me, all chummy, like something was up. And I remembered the dude talking about Andrea and Andrea's number in my pocket and I thought, maybe. But then maybe she went home with whoever I'd been hanging out with, and she was looking at me like a friend, like a third party who was there to witness her special moment. I started to think about how much I hate blacking out but instead decided to lay it on the table.

"Tell me," I said. "Do you happen to know where my truck is?"

Again, she smiled like I was trying to be funny. She reached into her pocket and pulled out my truck keys. I tried not to look surprised and felt more stupid than anything, roaming around all day. Looking for my truck and not even thinking about the keys to it, not even carrying them, not even realizing they were lost.

When I finished feeling stupid, though, I got a new feeling. I felt like taking another chance, like trusting that two and two still added up to what I thought it might. I picked up the keys and said, "Thanks, uh, Andrea?"

She smiled and said, "You're welcome," and I thought, score. Now I know who Andrea is and where my truck must be. I decided to push it one more, to get verification in another way, to see what else I thought I could know.

"And thanks for driving me home last night," I said. She smiled and I knew right then that we had the night before. I swore to myself that I would stay out of blackout on this night just in case I got the sequel. But I really wanted to get my truck. Not because I wanted to drive. Just because it's one of those objects that I recognize as reality. Like the bed I sleep in. Like the relief I feel when I'm in my own bed. I feel relief when my truck is outside waiting for me. So I asked Andrea how to get to her place. Told her that I hadn't been paying attention the night before. She said that I ought to know the way. That I'd lived in the same building.

"I'm going to grab my truck while I'm still sober," I said. "But I'll come right back after I get it."

I stepped back into the springtime sunlight and thought of all the places around town where I'd lived and tried to guess which one I'd been at the night before. She said the building, so I could stick to the apartments where I'd lived. And I'd lived in a complex straight down the road, so I waited for the next bus west.

While I waited, a black man in a white, African-looking robe and sandals, with a thin, white beard and a hat with no bill came up and stood next to me. He also wore dark glasses, like he might be blind or just trying to keep the sun out. But I thought he might be blind because I nodded to him and he didn't respond. Then, he asked me a question without looking at me. "Does this bus go to Florida A&M?"

"No," I told him. "You want to cross the street, catch the eastbound to the Civic Center, then catch another one south about four blocks."

He kept looking straight ahead and repeated the directions that I'd given him. I nodded, then thought about the blindness and said, "Yeah, you got it."

"Thank you, friend," he said in a deep, guttural voice and I couldn't tell if he had an accent or if it was the lack of southern accent that I was hearing. I sat on my heels. Buses came every twenty-five minutes and I didn't know when the last one had been by. The man kept looking straight ahead. I thought he might need help crossing the street.

"Say, man," I said. "Did you need help getting to the bus stop?"

"You have an open vibe," he said. "Are you a Sagittarius?"

"What's that?" I asked.

"When were you born?"

"August twentieth. Why?"

"A Leo," he said. "I wouldn't think."

Then I realized what he was talking about and wondered if maybe he was hitting on me. That old *what's your sign?* And I thought it was too bizarre to be annoying, to be hit on by a blind man in an African robe at a Tallahassee bus stop in the middle of a weekday. But then he broke into my thoughts with a statement. He said, "I must've been thrown off by your battle with reality."

Which, in itself made my battle with reality tougher. I looked up at him, amazed. "Do you surf?" I asked and he laughed. A deep, manly laugh. Like if Darth Vadar laughed. Then he pulled a string of beads out of his pocket, started rubbing them and mumbling in a strange language, different from mine and the Asian lady's.

When he quit mumbling, he quit talking. The bus came along a couple of minutes later and he hopped on. I tried to stop him before he paid the seventy-five cents, to tell him that he wanted to go east, not west, but he was done listening to me.

I sat on one of the seats that faced sideways. He sat across from me, near another black man who was sitting on one of the seats that

faced forward. The African guy turned to the man and said, "Your grandmother. Was she Cherokee or Apalachee?"

The man looked at the African guy but didn't answer. The African guy asked his question again, louder this time. The man squirmed in his seat, still not answering. The African guy looked at him, and I realized that the African guy wasn't blind. The man met his gaze and said, "Fuck off. Leave me alone." The African guy pulled out his beads and mumbled.

And I got to thinking that maybe the African guy was crazy, or maybe he just had another religion, and we were looking at him like someone in Botswana must look at a Catholic priest when he pulls out his rosaries and mumbles his Hail Mary. Because the other man did have a round face and high cheekbones and his hair wasn't very curly for a black man. It wasn't inconceivable that he'd have a Cherokee grandmother. And as for the beads, they could've been legitimate. I couldn't think of what religion the African guy might have been, but I'm no expert on world religions. I wanted to believe that that was the African guy's deal, regardless. That he was some high priest in America, maybe lecturing at Florida A&M, and I treated him right on a spiritual level and he said a prayer for me. And I fully realize that he could've been a nut, but I didn't want to side with the easy answer just because it was easy.

I hopped off the bus a mile and a half down Jackson Bluff at Mabry Street, then headed north up to Mabry Village. I'd lived in the back, but for no good reason I figured that Andrea could live in any building. I wandered around the parking lots, working from south to north, figuring that, if this wasn't it, I could catch another bus up Ocala Street and check out University Towers. My truck had to be at one apartment complex or the other and, either way, I could make it back to the Shack in plenty of time to not look conspicuous. My only worry was that one of those paranoid college kids would call neighborhood watch on me, seeing me wandering around the parking lot, checking out cars like I might be casing the joint. And for all I knew I was out on bail. But then I saw it. Sitting right in front of my old building. 309. Like I could be upstairs in apartment G, sleeping it off and the truck was just waiting for me to wake up. Right on. I cranked it up and headed out.

As I waited to pull out onto Mabry, I looked across the grounds of the State Penn, across the street. That must've been where the jail came from. I must've been in the same spot the night before, looking across

the prison grounds, thinking about leaving my truck, thinking about making the run the next day, thinking about the beautiful barmaid driving me home, and those must've been my strongest thoughts before I went to sleep.

And then I thought back to my junior year of high school, seven years earlier, just before my mom and I moved to Tallahassee. Living on the coast of Florida. Skipping school to go surfing. I thought about being young and not thinking and catching that first wave of a set so I'd get a weak ride and then the last two or three waves would all pound me once I bailed off the wave or ate shit. And I didn't have a leash so sometimes I'd lose my board and have to swim all the way in to shore to get it. I'd think of sharks swimming around below me, looking at me like I was a fat, tasty sea turtle. Thinking about the next wave I would catch. Swimming like hell just to get back out there. Thinking that I missed something with every wave I didn't ride.

Couch Space

I was drinking a beer on the front porch when the landlord pulled up in his little BMW convertible. He was a pugnacious little guy, dressed like a businessman on his day off: Gap t-shirt tucked into khaki shorts held up by a braided belt, calf-high Nike socks pulled all the way up, brand new white Nike sneakers. He stood by the car, took a deep breath, and stuck out his chest. The way that he did this and the way that he glared at the house and the way that his meaty lips twisted somewhere between a snarl and a whine all reminded me of a schoolyard bully. I was predisposed to dislike him before I met him. Seeing him made me downright loathe the guy.

Through the bedroom window, I heard Tracy's roommate say, "Put that away. The landlord's here."

"Fuck it," Tracy said. "He ain't our landlord anymore." Then, I heard the sound of gurgling water. Followed by the sweet, sick smell of pot smoke drifting out of the bedroom window.

Heather, who was another of Tracy's roommates, was standing in the driveway, chatting with her friend. I didn't know her friend's name at this point. I didn't care. All I needed to know about him was that he was the next sucker who owned a truck. My replacement.

Heather said hi to the landlord as he walked towards her. "I like your car," she said. "What kind is it?"

"BMW," the landlord said. I couldn't see him roll his eyes, but I assumed he did. At the time, this model was a popular trend among yuppie men. The BMW corporation had paid a movie studio big bucks so that James Bond would drive their car in his next movie. James Bond (or at least Pierce Brosnan) did, so suddenly the freeways of Atlanta were littered with balding, middle-aged men from Marietta in little black convertibles.

Heather apparently hadn't noticed this. Sometimes, Heather didn't seem to notice a whole lot of anything in general. "It looks like that other kind of car. What's it called?"

"It doesn't look like any other kind of car," the landlord said.

"No, it does," Heather said. "It looks just like those other cars. You know the ones I'm talking about."

"It doesn't look like any other kind of car."

Heather turned to the other sucker who owned a truck. "What's the name of that car, Nick? You know the kind I'm talking about."

"Mazda Miata," Nick said.

"Yeah, that's it. It looks just like a Mazda Miata, don't you think?" Heather said. "Anyway, it's cute."

"It doesn't look like any other kind of car," the landlord said again. He stormed off towards the house.

I felt that old schoolyard reflex kick in. I wanted to point and laugh at the landlord, "Heh-heh. You got scuffed." Because I knew that men ignored the Mazda and paid twenty-five thousand dollars more for the BMW solely for the dream that came with that car. The dream that driving it made you dashing and mysterious, and beautiful young women would love you for it. And here was Heather, who I wouldn't necessarily call beautiful, but she was young and really pretty, and the whole dream was lost on her. Beautiful young women not only didn't swoon over the car, they didn't even recognize that they were supposed to swoon. On top of it all, Heather called it "cute," which is the last word a forty-year-old balding guy wants to hear. The landlord stomped up the front porch steps and into the house. I laughed to myself.

Earlier that day, Tracy had called me. My first thought was, damn it, who gave Tracy my phone number? Tracy and I both worked in the same restaurant in downtown Atlanta, but we weren't friends, really. We got along fine at work, chatted sometimes, ran food for each other, but that was it. She'd have no real reason to call me on my day off, I figured, unless she wanted me to work her shift for her. Ordinarily, that wouldn't have been so bad, but this was my last day off for a month. And the second half of that month, the Olympics were coming to town. Things were about to get really crazy. I just wanted one day to be alone and chill out before the craziness. So, no, there was no way I was going to work a shift for Tracy. But when Tracy started the conversation by saying, "You have a truck, don't you?", I realized things were going to be a lot worse.

The bummer about owning a truck is that everyone bugs you to help them move. I'd had that truck for a long time, though, and had gotten good at saying no. My resistance was strong when Tracy started the conversation. But Tracy had a pretty good argument. Her landlord

had called her up that morning. He told her that he had managed to rent her house for the month of the Olympics. The new tenants were willing to pay three times as much money for two weeks than Tracy and her roommates paid for a whole month. So Tracy and her roommates had to go. That day. I tried to argue with Tracy, saying that he couldn't do that and that they should fight him instead of move, and so on. Tracy just said, "Look, he's got a lawyer, and we don't. We have to move. Will you help me?"

"One load," I said. "Then you've got to find someone else with a truck."

So I went over to Tracy's house and the scene was a horror show. All of their stuff was scattered throughout the house. Nothing was in boxes. They didn't even have boxes. It was clear that all three women there hadn't planned on moving when they woke up that morning. And they just weren't handling the situation well. Heather was on the phone, trying to line up a couch to sleep on for a month. Tracy sat in the middle of a pile of clothes, doing bong hits. Their last roommate, Carrie, walked around the house with a garbage bag, picking things up, saying, "Is this mine?" and stuffing them in the garbage bag if someone said, "Yes." It seemed hopeless until Tracy said to me, "Beer's in the fridge. Help yourself."

Helping your friends move can be a pretty depressing thing to begin with. Sometimes you see more about them than you want to. It's like looking at them naked, first thing in the morning, with bad lighting. It's even worse when there are no boxes, and you're stuffing things into garbage bags. You pick up a sun-yellowed, one-armed doll with thinning hair and ask a twenty-five-year-old woman what she wants to do with it. You watch her hug it and say, "I'll take care of Miss Peaches," and walk off. You pick up a folder of essays written in sixth grade handwriting, notice that Tracy got a bunch of C's, but two essays with A's and Good Jobs and stars drawn on top with a red pen. You want to read them really badly—just to understand why she kept them all these years—but stuff them into the plastic bag instead. And your day goes on.

I ended up hauling three loads of stuff to six or seven different places. Mostly, we'd carry bags up to apartments where someone would say, "You can use this closet," or "stuff all that shit under my bed." Everyone seemed to apologize about not having extra room on the

couch, saying they'd already promised their couch to their cousin or old high school friend or whoever else was coming to town for the Olympics. We took most of the furniture to a warehouse space just off of Auburn Avenue. I knew the warehouse well. A couple of times a month, the kids who lived there would throw punk shows. I'd been to a few of them. As I leaned Tracy's mattress up against the graffitti'd block wall, I wondered if it would still be leaning there when those kids threw their next show. (And sure enough, one month later, I saw her mattress, couch, and dresser standing to the right of the pit while three local hardcore bands played.)

Finally, Nick—the other sucker with a truck—showed up and took over for me. I grabbed a beer and sat out on the porch by myself to drink it. The summer heat was oppressive. The air hung heavy, thick, and dead still. But two big oak trees flanked the porch, casting down a less-hot shadow. And the beer was cold. I looked at my watch, idly contemplated calling a friend and going to the Braves game that evening, and eavesdropped on Carrie and Tracy, who were both smoking pot in the bedroom behind me. As their conversation gave way to long, deep breaths and bubbling water, I thought about why I'd agreed to help these women to begin with. Because I'm a sucker, I thought. And laughed at myself. But also because I probably think too deeply about life in general. Because, when Tracy called and told me about her landlord, the whole situation translated in my mind as something much larger. I thought: people like me and Tracy are the servers and the tenants, the ones who get our money a dollar at a time and know what life is like without enough of those dollars. We know karma as a real and living force. I know that I have to run food to Tracy's tables for her because I need someone to run food to my tables for me. I also believed that I had to help Tracy move because I had already been lucky enough to find a couch to live on during the one month when all the couches in town were full. So that's what gets me into messes like this, I decided.

I cursed myself for thinking too deeply and swore I'd stop. I let my mind drift to more pedestrian daydreams about punching that landlord in the mouth.

That's when the landlord showed up and when Heather turned his dashing, forty-thousand-dollar car into a cute, fifteen-thousand-dollar one. The landlord stomped into the house. I laughed to myself. I thought too deeply once again and realized that, no matter how much

the guy made from his new tenants during the Olympics, it wouldn't make up for the twenty-five thousand dollars he'd just lost on that car.

Tracy came out to the porch. She saw me there and said, "I thought you took off already."

I drained the last few drops of my beer and said, "I'm just about to."

"You want a beer or anything for the road? A bong hit?" she asked me. I shook my head. She pulled out a small wad of dollar bills from her pocket. "Let me give you some money for this," she said. She counted out probably fifteen or twenty bucks from her wad and held the money out to me.

I didn't move. "Put your money away," I said.

She held it out for another few seconds, said, "Are you sure?", then put the money back in her pocket. "I wish I could do something for you."

I could hear the landlord inside telling Carrie that she had to hurry, that the cleaning people would be there first thing in the morning. I heard him say that the cost of cleaning the apartment would come out of their damage deposit. I thought about this.

"There is one thing you could do for me, Tracy," I said.

A minute later, I heard Tracy in the front room, speaking loudly enough for me to hear. She said, "Whoever's got the Mazda Miata, you gotta move it. You're blocking Sean's truck."

The landlord didn't even argue this time. He stormed back down the steps with the BMW keys in his hand.

Sometimes, small victories mean everything.

Waiting For Thor

Waiting For Thor

I ran into Thor in Flagstaff last September. Not the Norse god Thor. The computer programmer Thor. I was in Flagstaff to talk to a couple of Creative Writing classes at Northern Arizona University and to do a reading. I'd shown up a day early because I used to live in Flagstaff, and I hoped to run into some old friends, one of whom was Thor. The problem was, I ran into him at eleven o'clock, and though bars stay open in Arizona until one, the hostel where I needed to get a room only stayed open until eleven-thirty, and they wouldn't let you in drunk. So I couldn't hang out with Thor that night. He convinced me to meet him the next night for happy hour at a bar called Cattle Baron's. I didn't want to do it. I had to do the reading at seven o'clock. I wanted to be sober for it because, if there's one thing I hate, it's all these writers who think they're Jack Kerouac because they get liquored up and stumble through the readings that other people are gracious enough to attend. But Thor promised that we wouldn't get drunk in the hour before the reading, and the reading was right across the street, so I agreed to meet him.

Cattle Baron's was and is my favorite place in Flagstaff. It's a real working class joint right down to the etched leather mural of a cowboy sleeping on a saddle, dreaming of a topless broad riding a cloud. I got that special swelling in my chest when I heaved open the big, carved wooden front door. I stepped into a familiar scene: two ranch hands hitting on two biker chicks, three Indians sitting directly in front of the Budweiser cooler, a handful of graduate students playing pool, and a young blonde bartender standing to one end of the bar, doing a crossword so that she wouldn't have to chat with any of the customers. I sat two stools down from the Indians. The bartender put down her crossword and asked me what I wanted to drink. I started to order a bottle of beer, then remembered Thor and ordered a pitcher. She handed me the pitcher and one glass. I paid, poured my beer, looked at my watch, looked around the bar, and looked at my watch again. No Thor. I took a sip of beer and listened to the Indians kidding each other. They

were obviously old friends because of the way two of them were always picking on one of them, but they rotated so that they all got equal time ganging up on someone and getting ganged up on. I eavesdropped heavily, stifling laughs so that I wasn't obvious. I drank one beer slowly, poured another, looked around the bar, and realized Thor wasn't going to show up. I battled with the thought of the whole pitcher of beer in front of me, trying to decide which I despised more, the Jack Kerouac wannabes who show up too drunk to read or the weaklings who can't finish all the beer that they were tough enough to order. As I rolled these thoughts around in my head, I noticed one of the Indians staring at me. "Hey," he said to me. "What are you sitting there all stoic for?"

I explained my basic situation to him, about Thor and not wanting to drink and the reading and all.

"What's a reading?" he asked.

I reached into the backpack leaning against my barstool and pulled out a copy of my book. "I wrote this novel," I told him. "And from time to time, I read an entertaining part of it to a crowd." I handed him the book. He looked at the cover and laughed and looked at the back of it and laughed and opened up to a page in the middle of the book, read a few lines, and laughed. One of his buddies asked him what was so funny, and he told his buddy, "That guy wrote this book."

His buddy asked me what it was about. "Drunk construction workers in Florida," I said. Sometimes I tell people what the plot is about. Usually, I just say the first crazy shit that comes to my mind. Never ask a writer what his book is about. He won't know what to say.

The second guy came around and sat between me and the first guy. "I'm a drunk construction worker," he said. I smiled. He saw the smile as an invitation to talk, and he started talking. He was Hopi, born on the reservation. After high school, he came to Flagstaff to work for a brick mason. After a while, he started taking construction classes at NAU. He worked his way up to mason, graduated with a contractor's degree, and ran a crew in Flagstaff for a while. Then, he had kids and wanted them to grow up on the rez. He moved back out there. The Hopi tribe isn't really growing, so the construction industry is all remodeling work. He told me about the government housing that his tribe lived in, the houses with plumbing running outside the wall, with bathtubs falling through the floors, with leaky roofs and wind howling through closed windows. Apparently, the government paid contractors a lot of money to build the houses. Rather than building houses as nice as the money they got for

them, the contractors hired drunks and unskilled laborers to build the cheapest shit they could. The only requirements were that it look like a house, and it stand until the check cashed. My new Hopi friend was out there trying to fix all of that, but his tribe is a poor one, and our government (never one to spend much on the people from whom they stole this land) won't pay to build the same house twice. So he had a dilemma. He wanted his kids to grow up Hopi. He wanted his tribe to have homes that kept them dry and warm. At the same time, he was out there working sixty hour weeks, never seeing his family, unable to get the materials he needed, not getting paid for half the work he did, and not able to support his family. He could move to Flagstaff and make good money doing less work, but it meant leaving the tribe, and it meant that his kids wouldn't have the experience of growing up with a tribe.

I nodded and drank as he told me all of this. In a lot of ways, I empathized. Although I don't have a tribe or a family of my own to support, I do know what it's like to work fifty hours a week, every week for a month and still not have enough money for rent. I knew about the cheap houses with day laborers because I'd spent two months working for one of those crews in Flagstaff. My boss was a crystal meth addict, the rest of the crew smoked pot until they were just shy of incapacitation, and we built new houses that shook in the wind. I started to tell the Hopi construction worker about this, but he said, "Hell, are we here to bitch or to have fun? We're here to have fun, right?" He poured what was left in my pitcher into my glass.

The other Hopi, in the meantime, started reading out loud from my book. He read a passage in which three old friends tease each other in a bar. Instead of reading the characters' names, though, he filled in his own name and those of his two friends. This made me feel so good that I gave each of my new Hopi friends a copy of the book. Then, I left for my reading somewhat drunk, cursing Thor but thanking him for dropping me in a situation where I got to meet those cool Hopi construction workers.

Despite the pitcher of beer in my gut, the reading went well. I made a bunch of new friends there, too. After the reading, we went back to Cattle Baron's, and we all got drunk.

The next day, I drove down to Sedona. It's a nice drive because Flagstaff is up in the mountains and very lush for Arizona. As you get out of the ponderosa pine forest of Flagstaff, you drive into huge, jagged rock formations that are ringed in shades of red from different

periods of geographical time. You've seen pictures of these rocks, whether you know it or not. Dead center in the middle of these red rocks is the town of Sedona. I tried to peddle my book to the bookstores, then I wandered around the downtown area of Sedona. The town is full of stores where you can buy Indian jewelry made by white ex-hippies who charge five times as much as the Navajos who have stands twenty miles up the road. You can buy forty-dollar arrowheads made by retired white people in Cottonwood. You can buy all the right crystals and stones and artifacts of the real Arizona: the one that markets and photographs well for *Arizona Highways*. Supposedly, Sedona is a vortex of new age healing energies. As far as I can tell, though, all that really gets sucked into Sedona is tourists looking for rocks and people wealthy enough to move into a place that's as expensive as the scenery is beautiful. I thought of all the wealthy Sedona New Agers searching for some new religion by trying to translate ancient Navajo beliefs into a Madison Avenue ad campaign. It made me think.

It's easy to love Indians and hate New Agers, especially if you don't look too far beneath the surface of the stereotypes. Americans love underdogs, and the Indians are the ultimate underdogs. Within recent history, all the Indian tribes were wiped out. It didn't matter whether they tried to acclimate into white society like the Cherokees or if they fought to the bitter end, like the Sioux and the Nez Perces. The result was always the same: a culture was lost. Most groups have problems. Indians have plights. New Agers, on the other hand, are ex-hippies who you know either sold out or cashed in, depending on your perspective. There's still a heavy dose of peace and love rhetoric, but most of them vote republican in November (or at least democrat, which is just as bad). New Agers embrace hundred-dollar rocks for the rocks' healing powers, but ignore the fact that some poor African spends twelve hours a day in a hole digging that rock out of ground that was stolen from him. New Agers dangle dream catchers from the rearview mirrors of their BMWs and listen to whale songs and reek of patchouli and are generally annoying. I thought about all this as I wandered around downtown Sedona. I thought about downtown Sedona itself. It looks like an old town square, but if you look closer, you notice that no building is more than twenty years old. If you look even closer, you notice that it's really not a downtown so much as a strip mall designed to look like a downtown. That's when things started making sense to me. This is when I'll finally get to the point.

Glue and Ink Rebellion

New Agers bad, Indians good. Sure, that's an easy, superficial way of seeing things. Most Americans think they love Indians because Americans love underdogs. That's the mistake. Americans don't pity Indians like you pity an underdog. Americans envy the Indians. Every last one of us does. The New Agers are a little more blunt about it, but each and every one of us, deep down inside, has wished at one point in our lives that we were Indians. Think of the old neighborhood games of cowboys and Indians. Remember how hard it was to get someone to be the cowboy? Cowboys wear silly hats. Indians wear war paint. Cowboys blow whiny harmonicas. Indians beat drums. But that's not the real reason everyone wants to be the Indian. It's because, even though the Indians are the most recent in a long line of indigenous cultures to lose out to a powerful, greedy, war-like culture, at least they lost out recently enough to remember their heritage. It's the ability to remember one's heritage that we envy. The losing out part is secondary, because most of us have lost out. Before the Indians, it was the Africans, ripped from their culture and enslaved in the United States. And you can try to reinstate some of that African culture that was lost. You can wear red, yellow, and green. You can celebrate Kwanzaa. You can give yourself a Swahili name, but you know all along that four hundred years of slavery and oppression leave a huge void and no easy way to fill it. Before the Africans, the English raided Ireland, stole all the land, forced the indigenous into impoverished tenant/landlord relationships. England learned this trick from the Vikings, who did it to the English first. Spaniards took over the Aztecs. Columbus wiped out the Arawaks. The Dutch took South Africa. The British took it from the Dutch. The French took Madagascar. The French and Spanish alternately took over the Basques. Ghengis Khan took a big chunk of China. China took Tibet. King Philip took a bunch of islands in the South Pacific and named them after himself. Brits took Australia from the aborigines. The Russians took Kazakhstan. And on and on. And where does this leave us? For most of us, it leaves us ripped away from the homeland and cultures that are natural to our genetic makeup. We're a bunch of mutts kicked out of our litter and left to roam around the world lost. Indians can remember their homeland and culture, so they're not quite as lost as the rest of us. That's why we envy them.

New Agers try to cling on to a living indigenous culture, even though it's not their own, because at least it's living and it retains some sort of purity. So we want to make fun of them (I do, anyway) because a bunch of lawyers in a drum circle looks fucking ridiculous.

Ridiculous because they're trying to be someone they know they're not. But we all do it. We embrace Christianity and what we're really doing is clinging to the superstitions of ancient Hebrew tribes as interpreted by the Roman elite. Judaism eliminates the Roman elite interpretation and just sticks with the superstitions of ancient Hebrew tribes, basing their beliefs on the beliefs of a people who went into war with a slingshot. Mormons take the silliness of Christianity and pile on top of it some goddamn New England farmer who found a bunch of golden tablets in a cave, and, lucky for him, he was fluent enough in ancient Hebrew dialects to translate the tablets before God took them back. Wealthy American college students and Japanese Sony executives alike embrace the old Indian (from India Indian) philosophy that all life is based on suffering as they surround themselves in every luxury and convenience modern technology affords them. And it goes on and on until all religions reek like patchouli in my nose, because, really, we're all trying to grasp on to some established belief rather than take the time to form our own.

At this point, though, organized religion leaves us no choice but to develop our own personal beliefs, because one thing is certain: if anyone in the past (prophet or peasant woman) ever really did figure out the meaning of life or the answers to any of the other eternal questions, you can bet pretty safe odds that some army came in and killed her, or some group of wealthy elite took her ideas and reshaped them into a means of making that elite wealthier. And where does that leave us? Sitting in a bar, waiting for Thor, stumbling into some kind of Hopi wisdom, spinning down a vortex, and walking away more confused than when we started. But, hell, are we here to bitch or to have fun? We're here to have fun, right?

Fifteen Bucks and a Cookie

Matt tossed his can onto the pile of empties in the corner of the porch. The can hit the top of the pile, which reached the porch railing, and tumbled midway down to where the empty beer cans plateaued on the way to the summit. This caused a few cockroaches to skitter out of their caves.

I watched the cockroaches run between the planks and under the porch. "Your roommate is gonna yell at you again," I said.

Matt's roommate hated the pile of beer cans in the corner of the porch. Her point was that the pile was a breeding ground for roaches and we should clean up after ourselves. Matt didn't deny the roaches, but his point was that a homeless guy came by the porch once a week and cleaned up the cans for us and sold them to the recycling plant. Since the homeless guy was actually making money off the cans, it should be his job to pick them up and bag them. And not that anyone asked, but my point was that, as long as Matt's roommate yelled at Matt and not me, the pile of cans wasn't my business. I finished my beer and tossed my can on the pile. More roaches skittered.

"Man, Bobby," Matt said to me, "I'm kind of drunk."

"Yeah. Me, too," I said.

"It's kind of early to be this drunk."

I looked at my watch. It was four-thirty in the afternoon. I nodded my head.

"You want another beer?" Matt asked.

"If you don't mind."

Matt walked past me into my side of the duplex to grab the beer in my refrigerator. I sat on the porch, watching traffic roll past—the tight-faced people in too expensive cars—waiting for my beer, keeping my eye open for Matt's roommate or more cockroaches.

When Matt came back with the beer, he said, "You know, all we do is sit on this porch and drink beer. You know that, don't you?"

I opened my beer and drank some. While sitting on the porch.

"Other people live full lives. They finish college and get up in the

morning and go to work and earn a living and raise a family, and we sit here and drink."

"Yeah," I said, feeling like, if those were the two choices—getting up in the morning, going to work, earning a living and raising a family or drinking on the porch—I was making the right one.

"Other guys go out and find girls and get laid, and we sit here and drink."

"Yeah," I said, feeling like, if *those* were the two choices—finding girls and getting laid or sitting on the porch drinking—I was making the wrong one.

"Other people paint paintings or start bands or read books, and we just sit here and drink."

"I read books," I said.

Matt ignored me. "Other people got up and did shit today, and we sat here and didn't do shit."

Actually, we had done shit that morning. I'd been sitting out on the porch reading when Matt had asked me to go to the plasma clinic with him. He was broke and wanted to make the quick fifteen bucks that selling plasma provides. He wanted me to go with him so that he'd have someone to talk to while he sat in the clinic waiting for the machine to separate the plasma from his blood, then for the nurse to put the blood back in his body.

I didn't need to sell plasma that day because I wasn't broke. I'd worked for a month at the beginning of the summer, digging footers and raking concrete for a construction crew. The hourly wage had been small, but I'd managed to get in enough hours to make enough money to quit working for a while and sit on the porch and drink until the weather cooled off a bit. So I didn't need the quick fifteen bucks that morning, but when Matt asked me to go with him, I empathized. I'd gone to give plasma by myself before, and I knew how it blew to sit in the clinic, stuck in a chair with a needle dangling out of your arm, a quart of your body's blood in another room, and a crackhead jabbering in your ear. I also knew that I'd get a free cookie when I was all done giving plasma, so I'd decided to go with him. I thought of all of this and said, "We did shit. We gave blood."

"I'm talking about living a sedentary life, and you're giving me semantics," Matt said.

I couldn't argue with that, so I just changed the subject. I talked about a band who was supposed to play that night. Matt talked about girls he'd had crushes on in high school. We slowed the pace of our

drinking, but we kept drinking. The pile of cans gradually got higher. One by one.

At around eight o'clock, a couple of friends of mine stopped by. One of my friends, Pete, said, "You get any phone calls today, Bobby?"

I thought about it for a second and said, "None that I can think of."

"What about yesterday?"

I thought some more and said, "Can't remember any."

"That's because your phone's disconnected."

"Really?" I said, not really surprised. "Damn."

My roommates were bad about paying bills. Actually, they were good about paying bills, they were just bad about having enough money to pay the bills, so our utilities got cut off often. It didn't really bother me all that much. Matt lived on the other half of the duplex, and if electricity was shut off, we'd just play his stereo and keep the beer in his refrigerator. And I really didn't use the phone that much. Most of my friends lived within walking distance. If I wanted to talk to them, I walked over to their house. It just pissed off Pete when the phone was disconnected. Other than that, I don't think it really mattered.

Pete went on bitching about my phone being cut off and other assorted things until he finally said, "Are you gonna come with us to check out this band tonight?"

I downed the rest of my beer, tossed the empty onto the pile, and said, "Yes, I am."

"Fine," Matt said. "Why don't all you fuckers leave me here to drink alone."

Matt was pissed off because the show was in a bar. Only people of legal drinking age were allowed in. Matt wasn't of legal drinking age. He didn't have a fake ID. Matt's point was that, when people start drinking together, they should stick together and not leave the guy without a fake ID drunk and alone while the rest of the people go off to a show. My point was that I'd given blood with Matt earlier, and that was enough. Now I had money and was going to go see some bands play. So Pete and our other friend and I went to the show.

But this isn't a story about going to a show. This is Matt's story.

Matt hung out on the porch alone. I'd left my front door unlocked so that he could still get at the beer in my refrigerator. He turned on my stereo and listened to an album and drank a beer. Traffic rolled past, but it was now dark. He couldn't see the tight faces of commuters. The

commuters were all home. Matt drank his beer and cursed me and Pete and the other guy. He sang along with the song. Then, he walked up to the pile of beer cans, thought briefly about picking the cans up, decided it would be better to just pick up one can, crush it, and throw it at a car. When he missed the car, he tried it again with another can. Then another.

When there were a half dozen smashed beer cans in the road in front of his porch, Matt gave up and sat back down. At this point, he realized that *his* phone still worked. Matt went into his side of the duplex. He called every friend he could think of to try to talk one of them into coming over to the porch to drink with him, but it was summer time in a college town. Very few of Matt's friends were around, and those who were didn't feel like sitting on the porch and drinking. Matt finished his beer, crushed the can, and chucked it onto the street. It landed right in front of a car. The car swerved over to the curb and stopped.

Matt contemplated running into his house and hiding from the driver of the car. Then, he noticed that my front door was still open. The light was still on in my living room. Matt realized that, if he ran, the driver of the car would walk into my house looking to find the guy who threw the can. The driver of the car may get angry and do some damage. So Matt decided to hide in the corner of the porch and see who came out of the car.

He heard someone walk up the steps to the porch. Followed by two more pairs of footsteps. Matt crept over to the railing, ready to jump off the porch and split, if need be. The footsteps came closer. The first person stepped onto the porch. In the light, Matt recognized the guy as my friend Jason. Still, Jason hadn't walked far enough into the light for Matt to recognize whether it was an angry Jason or a ready-to-drink Jason. Next on the porch was a short, thin, dark-haired girl. She couldn't have been more than eighteen and still wore braces. And next came a much more grown-up-looking girl with red hair and long legs. There was enough light then for Matt to realize that it was a ready-to-drink, didn't-care-about-the-beer-can-thrown-at-his-car Jason and his two friends.

Matt stepped out of the shadows and said, "Hey, there."

The two girls looked startled. Jason was startled, too, but he tried not to show it. He said, "Hey, is Bobby around?"

Matt told him no, that I'd gone to a show.

"Damn," Jason said. "I was hoping to hang out on the porch and

drink some beer."

Matt looked at the red-haired girl and smiled. She smiled back. Matt looked at his feet, but he still had enough confidence to say, "Well, the porch is still here and there's beer in Bobby's refrigerator. You're welcome to hang out."

Jason and his two friends decided to do just that. Jason introduced the two girls as Beth and Sandy. Matt wasn't paying close enough attention to notice which name went with which girl, and he forgot both of their names instantly, anyway. He'd been steadily drinking for the past five hours. He'd donated plasma that day. He hadn't eaten any dinner, and now he was throwing-cans-at-cars drunk and trying to maintain because he was suddenly floating through ether like Charlie Brown at the school dance after everyone had coupled up and all hope seemed lost until the little red-haired girl swept him off his feet. All right, Matt told himself, the little red-haired girl is all grown up. I have to deal with this right now, or I'm gonna spend my life kicking at footballs that some bitch is just gonna swipe away from me at the last second.

So Matt maintained. He got beer for all three of his guests. He brought an extra chair out from his living room. The dark-haired girl with the braces sat on the extra chair. Jason went into my house and found a cassette and played it. Matt sat next to the red-haired girl and tried to say something but couldn't think of anything to say. He finally decided to just open his mouth and let any words that wanted to come out come out. So he did. He opened his mouth and found himself saying, "I sold plasma today. They gave me fifteen bucks and a cookie."

Matt heard himself and wanted to slap himself on the forehead and scold himself for being so stupid. Luckily, though, he wasn't stupid enough to go ahead and slap himself on the forehead and scold himself, so he just smiled.

The dark-haired girl rolled her eyes and looked away.

The red-haired girl turned to face Matt and said, "Oh, really. What kind of cookie?"

Matt kept smiling, happy that the red-haired girl would at least humor him, but not happy enough to diminish his self-loathing. "Just a sugar cookie," he said. "It kind of sucked."

"That's too bad," the red-haired girl said. She kept looking at Matt. Matt kept smiling. He figured it was best just to smile.

"You ever notice that the plasma clinic is right across the street from the Greyhound station?" Jason asked. "You ever wonder about

that?"

"I don't wonder about that," Matt said. "It makes perfect sense to me. There's always some guy in there selling plasma to pick up a few extra bucks. Waiting out their Greyhound layover."

"Exactly," Jason said. "It all has to do with what I like to call the 'scavenger class.' See, when Keirkegaard discussed the conflicts of master/slave relationships in respect to class divisions…"

Matt was suddenly lost. He hadn't read Keirkegaard. He didn't know who Keirkegaard was. He couldn't equate selling plasma with scavenging and didn't really care. He wished he were back to talking about cookies with the red-haired girl. The other girl, the one who'd rolled her eyes at Matt, perked up when Jason started talking about Keirkegaard. She listened to Jason's whole diatribe, then started one of her own. Matt tried to listen. His mind drifted when she said the word "hegemony." Matt didn't know what a hegemony was. He had a sneaking suspicion that people who did know what a hegemony was would never use that word. People who knew what a hegemony was found better ways to talk about it. Matt decided that he despised hegemony and would have to forgive the rolling-eyes girl for saying it.

Pretty soon, the red-haired girl jumped into the conversation. She didn't say hegemony, but she said a bunch of stuff that made no sense to Matt in his plasma-weakened, beer-impaired layer of ether. He tried to follow, because, more than anything, he wanted to talk to this girl. But she mentioned names he hadn't heard of and concepts he doubted that she understood. This led to Jason mentioning other strange names and half-baked concepts, and the rolling-eyes girl doing more of the same thing. Matt's eyes darted back and forth and back again, from the rolling-eyes girl to Jason to the rolling-eyes girl to the red-haired girl, and he could hear the words and understand some of them, but he felt completely alone. He drank his beer and darted his eyes. He wished the three of them would just leave. Then, he remembered that he'd been bitching about never doing anything like finding girls, etc., and decided that he had to do something. The rolling-eyes girl was talking about a professor and what he'd said in one of her classes. When she paused, Matt said, "I take classes."

The rolling-eyes girl rolled her eyes. Matt's self-loathing raised itself to another level. The red-haired girl gave Matt a soft smile. "Really?" she said. "What classes are you taking this summer?"

"Bowling," Matt said, and immediately he wished he'd lied—said political science or organic chemistry or something. The red-haired girl

laughed. Matt knew he was sinking and decided to swim for a raft. "We should go for a walk," Matt said.

The two girls liked the idea. So did Jason. Matt suggested that they bring beer. The walk suddenly sounded even cooler. Jason and Matt went back to my bedroom, grabbed my backpack, dumped everything in it out onto my bed, then filled it up with beer. As they were doing this, Jason said, "You know, Matt, Sandy doesn't have a boyfriend."

"Really?" Matt said, trying to figure out which of the two girls was Sandy. "Does that mean that uh, uh, the uh…"

"Beth?"

"Yeah, Beth is your girlfriend?"

Jason nodded. Matt wished that the night was a book and he could just flip back a couple of pages and read over the introductions again and find out which girl was Sandy and which was Beth. Matt even thought about just asking Jason. Then, he decided that he knew the answer. Deep down inside, he knew that the red-haired girl was too pretty and too cool to be single and that the angry little girl with braces must be the single one. But what the hell, he figured. It's a nice night for a walk.

The duplex that Matt lived in was right across the street from the Tallahassee Civic Center. They walked over there, first, across the vacant parking lot, up the stairs, and alongside the huge glass walls of the Civic Center. The moon was new and almost all of the lights around the Civic Center were off. There was no traffic on the side streets. Everything seemed evacuated. It was strange to be alone in a place where you would normally be surrounded by thousands, even tens of thousands of people. Kind of eerie. The four of them walked away from the Civic Center.

They turned east up Pensacola Street and headed for the state capitol buildings. Matt lagged back a little so that he could walk with the dark-haired girl, who he decided was named Sandy. He didn't actually try to call her Sandy. He wasn't that brave or certain yet. He just noticed that Jason and the red-haired girl, Probably-Beth, had walked a bit ahead and Probably-Sandy had lagged behind. He felt sure that she was the single girl. Matt asked her about her classes, about her friends, about her hometown, anything he could think to ask. Probably-Sandy kept her answers brief. So brief that Matt finished his beer and grabbed another one out of my backpack and drank it on the hundred-yard walk up the hill to the State of Florida Supreme Court building.

Jason and Probably-Beth sat on the steps. They were waiting for Matt and my backpack full of beer. Matt gave them each a beer. He grabbed a beer for himself. Probably-Sandy wasn't drinking. She didn't think it was a good idea to walk around the streets drinking alcohol. Especially since they were all under the legal age to drink.

This didn't bother Jason, Matt, or Probably-Beth. They sat on the steps of the State of Florida Supreme Court building and drank beer. Matt said, "One time, me and a buddy of mine ate a bunch of acid and decided to walk up here to the capitol. Only, it was the middle of the day. It was like a Tuesday or something. So we're walking up here—we'd just taken the acid. It hadn't even kicked in yet, when we get up here to this building and see a bunch of fucking Klansmen. I started thinking to myself, Christ, I must be tripping. And of course I was tripping. But there really were Klansmen. Wearing the white robes and everything. Walking on that sidewalk right there. Holding signs and shit. It was crazy."

"What did you do?" asked Probably-Beth.

Matt took a sip of his beer and looked at the sidewalk where the Klan once marched. He looked across the street to the state capitol building. He let his eyes run up all twenty-two floors of the state capitol. He looked past it to the moonless night. Then he said, "We sat down on the sidewalk there..." Matt pointed across the street, to his right. "...and watched them and tripped for a while. Then a cop came along and told us that the sidewalk was state property and we couldn't sit there any more. So we left."

"You mean to tell me that the Klan was allowed to march on the state's sidewalk, but you weren't allowed to sit on it?" Jason asked. Matt nodded. "That's fucked up," Jason said.

"Yeah, well..." Matt said.

"Yeah, well we shouldn't be sitting here now," Probably-Sandy said. "Let's start walking back."

As they made their way back down the hill, Matt walked with Probably-Beth for a while.

"I liked your story about tripping acid with the Klan, even though it was sad," she said. "I have a happier story about cops and the capitol building."

Probably-Beth told Matt about a protest that happened about a year before. The Gulf War was just about to start. A lot of the students were protesting it. Probably-Beth and two of her friends brought a bunch of glass vial stink bombs to the protests. They threw them at

cops' legs when the cops weren't looking. The vials would break on the cops' legs pretty easily, and all the stink inside would bleed onto their pants. "The cops never knew what hit them," she said. "They'd just brush their legs like a bee had stung them or something. Then you'd see them walking in circles like they were trying to get away from the stink." Probably-Beth smiled.

She told him a few more stories about crazy things she'd done. Matt listened. He finished the beer he'd been drinking on the courthouse steps and opened another one. He drank too quickly because he was excited and nervous to talk to Probably-Beth. Probably-Beth drank quickly, too, but she was only on her third beer of the night. She hadn't sold her plasma. She had eaten dinner. Matt should've known better than to try to pace his drinking alongside her, much less drink faster. But Matt wasn't thinking clearly. In his mind, he was Charlie Brown finally dancing with the red-haired girl in a cloud of ether. In his mind, he floated and danced and drank and walked downhill from the capitol and stumbled into alcoholic blackout.

Though he'd been awake and alive and continued to drink and talk and walk and everything else, Matt's memory of that night ended exactly halfway down the hill from the capitol building. From Matt's point of view, he'd taken one step on that downhill stroll that landed him awake in his bed ten hours later.

My memory lasted through the night. I'd gone to the show and stopped drinking. Five bands played. I spent the better part of the evening dancing around in circles and bumping into people. While the last band played, I saw my friend Jason, his girlfriend, and her friend Sandy standing over by the bar. I was kind of surprised to see them. All three were under the legal drinking age. I walked over to say hello to Sandy. I liked Sandy a lot. She was an irreverent girl. She also had a thing for drunk losers. I was a drunk loser. The math was easy.

As soon as I got there, Jason handed me a beer. The band was loud. My ears rang. I could barely hear Jason when he said something about drinking all my beer. He said something else about Matt. I missed most of what Jason said about Matt, but I heard very clearly "spent all night hitting on my girlfriend."

The pile of beer cans was gone the next afternoon. The homeless guy had been by to pick them up. Matt gave him a peanut butter and

jelly sandwich. Matt also stole a can of Coke from his roommate and gave it to the homeless guy. The homeless guy sat on the porch. He ate the sandwich and drank the Coke. Then, he walked off with a plastic bag full of empties and cockroaches.

Matt's fifteen dollars of plasma money was down to five after the beers from the night before and after buying breakfast on the way to bowling class. Matt took his five dollars to the gas station down the street. He bought four quarts of malt liquor for eighty-nine cents apiece. He bought a stick of beef jerky with his last dollar.

I found Matt that afternoon. He was sitting on the front porch, drinking a quart of malt liquor and gnawing on a stick of beef jerky. I walked past Matt and into his side of the duplex. I walked back to his refrigerator. I saw three quarts of malt liquor. I took one. I walked back out to the porch and sat next to Matt.

"I'm an idiot," Matt said.

"Yeah," I said. Not necessarily agreeing. Just letting Matt do the talking.

"Did you talk to Jason?"

"Yeah."

"When? I thought your phone was cut off."

"It is," I said. "I saw him at the show last night."

"How'd he get in? He's not twenty-one."

"Sometimes people who aren't twenty-one go to bars," I said.

Matt looked at the floor. I did, too. In the empty spot where the empty beer cans had been, a roach popped his head up through the floorboards. His antennae flicked in the wind. He seemed momentarily lost. Or maybe I was giving him human characteristics. Maybe roaches don't have destinations in mind. Maybe roaches are never lost. Maybe roaches just assume that they are where they are supposed to be. Maybe the roach was in the right place, and Matt was lost.

"Anyway, I'm an idiot," Matt said.

"Oh, yeah?" I said.

"I think I spent a lot of time hitting on Jason's girlfriend."

"Yeah."

"Is that what Jason told you?"

"Yeah."

"I couldn't help it. She was so sexy and so nice to me."

"Yeah," I said, but I was kind of surprised. Jason's girlfriend was never nice to me. She was a condescending girl. She always wanted to have half-baked philosophical conversations. She didn't understand

what she was talking about half the time. She usually rolled her eyes at me when I tried to change the subject. I didn't bring this up to Matt. I sipped on the top of my quart.

"And I dug her red hair," Matt said.

"Sandy's?" I asked.

"Is that what Jason's girlfriend's name is?"

"No," I said. "That's what the red-haired girl's name is."

This caused a lot of confusion. It was a hot summertime afternoon in Tallahassee. Both Matt and I drank way too much to achieve clarity. All thoughts had to fly through heavy cloud coverage. All understanding came and went quickly. Despite our obvious mental difficulties, without the aid of memories or eyewitnesses, we reconstructed Matt's night. Obviously, things had been going well with Matt and Sandy. They walked down the hill from the capitol and told stories. They laughed with each other. It was a nice night. Jason and Beth walked ahead. Things seemed right. Matt couldn't believe it. So he didn't believe it. He made up his mind that he was hitting on the wrong girl. He decided that the red-haired girl was too cool for him. The red-haired girl was too cool to be single. He decided that he'd better face facts and deal with his options. When the four of them got back to the porch, Matt started hitting on the little angry girl instead. Since Matt was mistaken, since the little angry girl was Jason's girlfriend, things ended poorly. Jason, Beth, and Sandy left the porch. They went to the show and caught the last band. Matt stayed on the porch and drank one more beer and went to sleep.

"I'm an idiot," Matt said. His point was that other men live full lives. They meet women and get laid and get married and get jobs and earn a living and raise a family while Matt sits on the porch and drinks. And not that anyone asked, but my point was that Matt wasn't an idiot. He just spent too much time looking across the street at expensive cars and civic centers and capitol buildings.

Future events shined some light on this. Jason gave us the eyewitness account of the night. Matt's self-loathing had led him to hitting on Jason's girlfriend. Sandy had been interested in Matt, but she never would be interested in him again. I still keep in touch with Sandy. Her address changes a lot. Last I heard, she was doing stuff for a pirate radio station somewhere in Minnesota. Matt eventually graduated from college. He found a girl and got laid and married that girl and got a job and bred. He started drinking Scotch at the age of twenty-five. Now he earns a living and does all the things that come easily if you don't ask

big, obvious questions. He commutes tight-faced in a too expensive car. He gets drunk at home on Friday nights. He spends a lot of time wishing he were still on that front porch in Tallahassee in the summertime.

I've Got a Bad Feeling about This

I've Got a Bad Feeling about This*

A few years back, I shared an apartment with a guy named John. John was a *Star Wars* fanatic. Before moving into that apartment, I'd seen all three of the original *Star Wars* movies a few times and liked them, but I never thought too much about them. Right after the original *Star Wars* came out, I had a baby-sitter who sketched Luke Skywalker over a hundred times. Most of the sketches showed Luke holding the light saber in front of his face, blue eyes staring intently, hair feathered perfectly. After that, I thought of *Star Wars* fanatics as pimply, teenage girls who couldn't get dates, so they'd spend Friday nights yelling at seven-year-old boys and drawing pictures of really bad actors. John, though, helped me to see the light.

John was definitely an atypical *Star Wars* fanatic. He was an ex-Marine, a veteran of the Gulf War, a real cool guy, and a bit of a ladies man. He was kind of like a living Fonz, only without the whole thirty-something-man-hanging-out-with-high-school-kids creepiness about him. Yet, he still had a three-foot plastic Darth Vadar in his closet. In the original packaging. Next to a box full of Obi-Wans, Stormtroopers (regular and white-caped for the snow), Luke Skywalkers (regular and Jedi-robed), Princess Leias, Boba Fetts, and so on. He hung *Star Wars* posters on the walls of our living room. He watched the trilogy with women whom he thought he may get serious with. He watched the movies alone. Often. It baffled me. I had to understand. I started watching with him. I asked questions, and he filled me in on the back story. He knew all the trivia about every sound effect and every planet and every character. Gradually, I came to understand.

Before written languages, oral cultures passed down epic tales. Everyone in the culture memorized the epic, and in that way, the culture passed its values down through the generations. We also can learn a great deal about ancient cultures by studying their epics. Humanities classes help us through the *Iliad* and the *Odyssey*, and through them, we

*AUTHOR'S NOTE: This article was originally written during the summer of 2000. For this reason, some things may seem a bit dated. I chose not to update the article because I think it's very representative of the time when it was written and the time period that it was written about.

learn about ancient Greek values. We understand ancient Greek navigational patterns and sexual practices and warring tactics. We understand ancient Greek governmental systems and religions. We can then move on to the *Aeneid* and figure out what the Roman Empire copied from the Greeks and what they held important on their own. We can learn a great deal about Middle Ages England from Arthurian legend. If we do enough research, we can find similar epic tales that existed everywhere from Ireland to Japan. But no true American epic ever existed. Longfellow tried it with *Hiawatha*, but it didn't really catch on. And some could say that the Bible is our defining epic, but I'm talking about epics that people not only know, but memorize, and how many people in our culture really know the Bible? If people say they do, ask them about the part where Lot gets drunk and has sex with both of his daughters. I guarantee they won't recognize that part of the book. For a while, it looked like America would never have its *Iliad* or *Odyssey*. Then, in 1977, *Star Wars* came out. Almost everyone in America saw it. Almost everyone in America memorized it. It exemplified American values and allowed those values to be passed down through generations. Now we can study it and understand what those American values really are.

The first *Star Wars* movie is easy to dissect. A lot has changed in our society since 1977, and hindsight brings lucidity. The plot is classically American. You have an all-American kid, blonde hair, blue eyes, working on a farm. The farm is on a planet called Tatooine. I'm not sure what language the word "Tatooine" comes from, but I know that it's a place with wide open spaces that makes everything look dead; the people there struggle to grow food in overworked soil; weird people drive around in big, rust-colored trucks and sell junk farm equipment that often breaks down before you get it home; dangerous people live in the hills, and they may just shoot you for driving through their towns. All of this leads me to believe that Tatooine translates to the stereotype of the Midwest. So in this stereotypical Midwest is an all-American boy who just wants to go into town to buy "power converters" (which may or may not be a Holley carburetor), when, out of nowhere, a war is thrust upon him and he has no choice other than to fight it. First, he needs a team, so he joins up with a small time punk who has a fast ride and loves to work on it, and the punk's buddy, a long-haired guy who doesn't say much, just hangs around and helps out in fights. The Midwest farm boy and his two greaser buddies then go off to war.

The bad guy is Darth Vadar. You can tell he's a bad guy because

he's trying to take over the Midwest, just like the Soviet Union was trying to do in the seventies (according to most people who lived in the Midwest in the seventies). So the blue-eyed blonde farm boy and the two greasers team up with a sexy woman, goof around in their hot rod for a while, then get down to the business of killing everyone in the evil empire. It's a simple Cold War tale. It reads like a National Security Council document from the fifties. Good is purely good. Evil is purely evil. Everyone leaves feeling happy that the good guys spent all their money buying elaborate weapons.

The Empire Strikes Back continues the Cold War myth, going so far as to begin on a planet that is all ice, and ending with a main character frozen. *Return of the Jedi* admits that the Cold War has begun to thaw. Out of the ice surfaces cuddly creatures that appeal more to the lucrative children's market. And we all got stuck watching what seemed like a Disney ending. It was a fitting way to swing us into the Reagan years: full of national pride, lots of weapons, and unbridled consumerism. Hindsight makes all of this easy to see. What seemed to be hidden deeply in the camouflage of the day is now glaringly obvious in the same way that it's glaringly obvious now that Ronald Reagan wasn't really a president as much as he was an actor who the Republican party hired to play president. The values of the *Phantom Menace* may be hidden as deeply in the camouflage, but, as a kid who has grown up on the first three *Star Wars* movies, and as an adult who has experienced the secondhand *Star Wars* fanaticism, I'm more prepared to see what's going on underneath the *Phantom Menace*.

Shortly after the *Phantom Menace* came out, I ran into an old friend of mine, Murtaw. Murtaw and I had gone to graduate school together, and, for years, we wrote for the same magazine. We tend to agree on most political and social issues, so when something new surfaces, we like to approach the subject and compare notes, to see if the opinions we have formed separately are still similar. Running into Murtaw last summer and finally getting a chance to sit down and chat with him, one of the first things that came up was the new *Star Wars* movie. He asked me what I thought of it.

"I liked it," I said, because I did. I don't want all of my criticism to give you the impression that I hated the movie. I liked it.

"Really? I had serious problems with it," Murtaw said.

I asked him what the problems were. He answered by asking me to describe the plot to him. "You've seen it?" I asked.

"Yeah. I just want you to put the plot in your own words."

So I thought about it for a while and said, "A greedy, powerful group called the Trade Federation force an embargo on a planet. This causes that planet's people to starve, so a couple of Jedi knights go to the members of the Trade Federation and try to work out a settlement. When they can't, they bring the Queen of the starving planet before a congress that does nothing, so everybody fights in the end." I paused, thought about what I'd said, and said, "That's pretty much it, isn't it."

Murtaw nodded. "Not a very good plot, is it?"

Well, no, it's not a very good plot. But I didn't want to admit that, so I scowled and shut up. I didn't bring up the subject again until Thanksgiving weekend, when the leaders of a greedy trade organization got together to force embargoes which would result in people starving. Our leaders and congress did nothing about it, so everyone fought. This time, though, it was no movie. It was a protest against the World Trade Organization, and it was exciting. I couldn't help drawing parallels between the "Battle in Seattle" and the *Phantom Menace.* I called up Murtaw and finally made my counterpoint. He called me a fanatic but agreed to watch the flick again when it came out in video.

I, myself, was slow to rent the movie again, mostly because I don't rent movies all that often, and usually when I do, I like to rent things I haven't seen yet. Also, I'll admit it, I was afraid of genuinely becoming a fanatic. Then, I saw a picture of Natalie Portman on the cover of some magazine. It sat in a rack next to a magazine with George W. Bush on the cover. It reminded me of something that had bothered me about the movie when I saw it in the theaters last summer. What bothered me was Queen Amidala, Natalie Portman's character. It didn't bother me that the nation was ruled by a fourteen-year-old girl. I could suspend disbelief on that. What bothered me was that she was both a Queen and an elected official. I couldn't understand that. How does a democracy have royalty? Isn't everyone equal in a democracy? Shouldn't a person's bloodline have nothing to do with her ability to rule a country? And if that's the case, then isn't it either a ridiculous coincidence or a sign that something is seriously corrupt with the electoral process if a country elects a ruler based on who her parents were? This threw me off right away last summer. Now, one year later, I'm living in a "democracy" where supposedly no royalty exists and bloodlines have nothing to do with who gets elected as the ruler, yet, after the first Tuesday in this coming November, my ruler will be the son of a former president or the son of a former senator from Tennessee. Either way, he'll be a man who was born into wealth, privilege, and the American

aristocracy. So now Queen Amidala really pisses me off because she translates as either King Al Jr. or King George W. And remember, it was a King George from whom Americans first fought to free themselves.

I could've accepted the plot parallels between the *Phantom Menace* and the WTO riots if they'd existed by themselves. I could've accepted the parallels between an elected queen and an American election ruled by royalty if those parallels had existed by themselves. When I combined the two, I became mildly obsessed, went down to my local library, checked out the *Phantom Menace*, and proceeded to look for more insight into our modern society. What I found shocked and amazed me.

The first very telling thing about American culture came when the Jedis found themselves on Tatooine. The Trade Federation had already landed on Naboo and took over the people there. The people of Naboo were suffering greatly. The Gungans, who also lived on Naboo but were segregated from the humans on Naboo, were in a great deal of danger. The Jedis and Queen Amidala were on their way to the senate to clear everything up when the hyperdrive generator on their ship blew out. The Jedis and the Queen land on Tatooine and find a trader, Watto, who has the hyperdrive that they need. Watto, however, won't accept the currency that the Jedi offers him. This launches the Jedis and the Queen into a long, complex, and extremely risky plan which includes putting a young slave boy's life in extreme danger. The likelihood of the plan actually working is also very low, but the Jedis and the Queen (and the young boy's mother) see no other choice, so they go through with their plan. Now, I understand that all of this is necessary, in the context of the movie, for the advancement of the plot. I accept that. My problem, though, is that I see another choice. They have money. Watto just won't accept it. The part that they need is right in front of them. Watto's ownership is the only thing that's keeping them from taking it, fixing their ship, ending the suffering of half the people on a planet, and preventing the other half of the planet from being taken over. Doesn't it make a hell of a lot more sense for the Jedis to just take the part, fix the ship, and leave the planet? Yes, they would be stealing the part, but, ethically speaking, what's more important: paying a man the proper amount of money for something in his possession, or ending the suffering of the masses and protecting the life of one young boy? The answer is clear in America. It's more important to pay for property. Money always takes precedence over the well-being of the masses. That's the way the system is set up. America is not a humanitarian

country. It's a capitalist country. The great majority of laws and legislation are geared towards protecting property at the expense of the people. That's why the US is the only industrialized nation in the world that doesn't have a universal health care system. That's why law enforcement and prisons siphon so much money away from education. That's why no dole exists for the downtrodden, but McDonald's gets millions of dollars to bring Chicken McNuggets to China. That's why unions have been crushed. The Jedi, Qui-Gon Jinn, knows this, so he doesn't even contemplate taking the hyperdrive generator. Instead, he puts a boy's life at stake and leaves everyone else to starve. And when it's all said and done, they pay the man. Like good Americans.

The precarious plan to which the Jedis and Queen subject the boy involves a pod race that's straight out of NASCAR, right down to the smarmy, catch-phrase-obsessed color commentator, the rich guy in the sky box, and the dangerous hill people hanging out in the infield. Essentially, Qui-Gon Jinn bets his ship and the future of the people of Naboo on the pod race. They enlist the help of the slave boy, Anakin Skywalker. The fact that Anakin is a slave brings about two interesting parallels. First, the Queen responds to Anakin's slave status by saying that she didn't think slavery existed anymore. But she's a queen. Shouldn't she be up on foreign affairs? It reminds me of the time Kathie Lee Gifford supposedly first heard that her line of K-Mart clothes were made in Southeast Asian sweatshops. Kathie Lee acted as if she hadn't known all along, as if she couldn't possibly share the blame. But she sponsored those clothes. Shouldn't she have known something was up when she was paid millions of dollars to endorse clothes that sold for ten bucks, retail? Of course slavery still exists in the galaxy. It doesn't matter if it's Naboo, Tatooine, or Manhattan, if people live in castles and don't have to work, of course there's a slave whose work fuels that economic inequality.

Qui-Gon Jinn and the Queen tell Anakin that they're not on Tatooine to free the slaves. They're more interested in affairs at home, which, in all fairness, need their immediate attention. Qui-Gon Jinn does free Anakin, though, after Anakin wins the pod race. The rest of the slaves in the Tatooine ghetto, the ones who don't demonstrate a proficiency in pod racing, are left to wallow in their poverty. They have little hope for outside help in the form of Jedis fighting for their freedom. This is the second interesting parallel because it is awfully similar to American ghettos, where kids who show great proficiency in a spectator sport are freed from their impoverished fate while the rest of

the poor are left to wallow in the ghetto. And the outside help they receive in the form of insufficient social programs and underfunded educational systems leave them little hope.

The strangest, most glaring America/Tatooine similarity comes with Anakin's freedom. Qui-Gon Jinn is incredibly impressed with Anakin. Anakin has volunteered his pod and his pod race talents and asked for nothing in return. Anakin's success directly aids Qui-Gon Jinn on his mission. Anakin proves to be a smart, good-natured, and selfless kid. His unique talents make him a perfect candidate for Jedi training. Qui-Gon Jinn even believes that Anakin is "the chosen one." Yet, before Qui-Gon Jinn barters for this amazing kid's freedom, he gives the kid a blood test. How representative of the nineties is that? In a society so obsessed with the contents of a person's blood and urine that the results of a blood or urine test are more important in the hiring process than a person's intelligence, good attitude, work ethic, unique talents, and education, I guess it just makes sense that our heroes and saviors should have to stand up to a blood test, too. I guess it's not so absurd if the practice started long ago in a galaxy far, far away.

The parallels between Tatooine and America are most likely unintentional. George Lucas, when writing the *Phantom Menace*, probably tried to create a bizarre and imaginative world, and, to make this world believable, he anchored it in the society surrounding him. It is not my contention that Lucas was attempting to suggest to his viewers that money is more important than people; that royalty generally maintains power, even in a democracy; that most kids in the ghetto won't make it out of the ghetto unless they're great athletes; or that blood and urine tests are the best ways to screen employees. More likely than not, these are all cases of a society's values being so ingrained in a writer that he doesn't realize he is promulgating them. When the main characters reach the senate, though, Lucas is clearly taking overt political jabs. Shortly after arriving on the galactic capital of Coruscant, Queen Amidala is informed, "There is no civility, only politics... the senate is full of greedy, squabbling delegates. There is no interest in the common good." Also, the supreme chancellor (the president) has "little real power. He is mired by baseless accusations of corruption." This isn't subtle. This isn't a hidden meaning. This is authorial intrusion. The movie even goes on to show the actions of the senate, which essentially amount to a group of bureaucrats who respond to crimes against humanity by appointing a committee whose job is to do nothing. The bureaucrats are all on the payroll of the Trade

Federation. This isn't just a parallel to the legislative and executive branches of the American government. This is a direct attack.

It's probably no coincidence, either, that the man who turns out to be the purely evil force in the galaxy is a politician battling for "free trade."

What really breaks my heart about the parallels between the *Phantom Menace* and the society I live in, though, is the battle at the end. More specifically, what breaks my heart is the role of the Gungans in the battle at the end. When Jar Jar Binks first entered the movie, I noticed his Jamaican accent. I wondered at first if the Gungans were supposed to relate to the Jamaicans in the same stereotypical ways that the greedy businessmen of the Trade Federation had Japanese accents and the gangster/junk merchant had an Italian accent. I also thought that the Gungans might be Jamaican because their ears look a lot like the hairstyle of a rasta guy who lived in my old neighborhood in Atlanta. The more I thought about it, though, the more I realized that a direct line couldn't necessarily be drawn between the Jamaicans and the Gungans. The Gungans relate to a broader demographic.

The Gungans are innocent bystanders forced into a battle, unlike either the people who live within the Trade Federation or the people of Naboo. Throughout the movie, we are told that the people of Naboo are starving and otherwise suffering, but we don't ever see any of the people of Naboo, with the exception of their politicians. We have no idea what a town in Naboo looks like, what the customs of Naboo are, or what the overall quality of living in Naboo was before the Trade Federation came along. All we know is that the people of Naboo are starving due to an invasion by the Trade Federation. Therefore, in the context of the movie, the Trade Federation is bad. But we don't know anything about the federation, either, except that two of their leaders are unethical. But is there more to the actions of the Trade Federation? We don't know. It reminds me of the popular American reaction to the bombing of Yugoslavia last year (right around the time the *Phantom Menace* hit theaters). We knew that the people of Kosovo were starving and otherwise suffering, but we didn't ever see much of them. The mainstream media didn't explain much about the Kosovan refugees, what their lives were like, what their customs were, or anything like that. Likewise, the people of Yugoslavia and the nature of their conflict with the Kosovans was completely ignored. The mass media presented only one important bit of information: that Milosovic was "the next Hitler." Therefore, we knew that the Kosovans were good and the Slavs

were bad. The movie, the American government, and the mass media demanded that we not ask any more about the situation. Good is purely good. Evil is purely evil. There is no room in between for questioning the powers that be.

But I digress. We're talking about the Gungans, here, and what breaks my heart about their part in the battle. The Gungans, unlike the people of Naboo and the Trade Federation, were suffering long before the movie started. We can see that. We can see that the Gungans have been forced to live underwater even though they are clearly not aquatic creatures. And this was before political disputes between the Naboo and the Trade Federation brought on the invasion. We can also see that the resolution of the trade disputes won't make life any better for the Gungans, but their quality of life will continue to get worse until the disputes are resolved. So I put this equation together:

Receiving all of the negative aspects and none of the positive aspects of a global economy
+ Forced to live in completely unnatural conditions

Working class.

So, of course, when it all comes down to the battle, who has to actually fight it? Is it the poor, invisibly suffering Naboo middle class? Of course not. It's the Gungans. The working class fighting a war to keep the rich in power. Queen Amidala's plan couldn't be more transparent, too. Essentially, her plan calls for the Gungans to walk out into a field and get shot at and die until she can get back into her castle. What kind of plan is that? Where are the middle and upper classes of Naboo? They benefit from the global economy. Why don't they stand out in the field and get shot? They're the ones who are so dependent upon trade that they can't even feed themselves on a lush, green planet like Naboo. Why don't they fight their own fights? Why do the poor folks who get nothing from the government always have to die for the government? Why is it always the working class?

Queen Amidala gets into her castle, though. She remembers the Gungans. She treats them well. The movie ends before she can force them all back into the swamps. This allows me to calm down and remind myself that, by and large, it's just a movie.

All of this begs questions about life imitating art and about the intentions of the author. Neither of these questions interest me too

much. As I mentioned earlier, I don't believe most of these parallels are intentional constructs of George Lucas. The subtle ideas hidden in the *Phantom Menace* exist in the movie because they exist all around us. By and large, they are rarely articulated notions that lead to a number of the problems that our society faces today. The antidote to these problems exists just as subtly, though, in all four *Star Wars* movies. It's packed in a little frame and given a number: R2-D2.

Think of that little guy. In the first movie, he led Luke to Obi Wan. He carried the blueprints of the Death Star in his database and delivered them to the rebel forces. Then, he was co-pilot, navigator, and mechanic on the ship that destroyed the Death Star. He even stopped the trash compactor from crushing all the protagonists. In the second movie, he drove Luke Skywalker to Yoda and went through Jedi training with Skywalker. In the third movie, he helped spring Han Solo and Princess Leia from the grips of Jaba the Hutt, and he picked the lock to the shield generator, which allowed Lando Calrissian to blow up the Death Star again. In the fourth movie, he restored the protective shield to the escape ship, and he jacked up the hot rod pod. He also disabled the auto-pilot on Anakin's starfighter, thereby saving Anakin's life and giving him the chance to blow up the droid ship. This, in turn, disabled all the warriors who were killing the Gungans. Basically, of all the protagonists of all the *Star Wars* movies, R2-D2 was the hero. He saved everyone's ass and no one saved his. And no one ever really acknowledged him as anything more than a cute bucket of metal. But if you pay attention, R2-D2 teaches us that the unrecognized little guy has all the power. He builds and fixes things. He's a courier, navigator, mechanic, student, radical, and electrical technician; he's a laborer and a grunt. His ability to do the actual work and apply himself to a cause allows him to win his freedom. To hell with the soldiers and politicians. Everything depends upon that little guy.

Bulldog Front

Bulldog Front

Louis started it. I want to get that out of the way first. Louis started it.

The kitchen told the story of the last two weeks. We didn't go into the kitchen too often, and it was way too fucking cold to empty the trash, so two weeks worth of debris swallowed the kitchen. Littered with empty boxes of Hamburger Helper, pizza boxes, Taco Bell trash, everything else you didn't really have to cook first. And, for every empty two liters of RC Cola, there were 1.75 empty liters of whiskey. We'd started on Beam, worked our way through Early Times and Tom Sims, and were onto Old Crow by the time shit started getting really nasty. Or really, Louis started getting nasty.

We all knew the tragedy of his girl. She had herpes, so, on top of all the other shit, Louis had flare ups to deal with. Which meant we had flare ups to deal with. And fuck giving the guy sympathy. It was the heart of winter. If there were any chicks in town, they were in hibernation, and if they weren't, you had to admit that we were. For two weeks we'd been more or less snowed in. Sitting around the common room, drinking booze, watching the same old videotapes again and again. Never leaving except to get more booze, more soda, more food we didn't have to cook.

The shit started over *Fast Times at Ridgemont High*. A seemingly harmless movie. And no harm came from it during the first four viewings, but then, I guess we were all sitting there, watching Jennifer Jason Leigh prone in a dugout, thinking, shit, I was getting more in high school. And Phoebe Cates can be pure torture when you've been staring at the same four dudes for fourteen straight days. My voice added to the problem, too. The Spicoli jokes were inevitable. Louis started those, too.

Started harmless. "Hey, Eddie, do me a favor," Louis said the first time we watched it. "Say, 'I know I'm in the right place. I see the globe right there.'"

I said it the first time. And the second and the third. Snowed in or

not, I was still pretty happy about shit in general. My first winter up north, union pay coming in every week that the ground stayed frozen. My bones felt like they were getting stronger, my joints didn't ache when I got out of bed, the calluses were shedding layers. This was the first time since elementary school that I'd had two weeks when I didn't work or look for work. I'd even been picking up an extra twenty bucks almost every time I went to the liquor store by pulling some poor sap out of a snow bank with my truck. No doubt, man, I was loving it. Paid vacation, the two most beautiful words since "open bar," Still, by the fifth generation of Spicoli jokes, I'd had enough, so I told Louis flat out, "Be cool, Louis. I've had enough."

"Come on, dude," Louis said. "Surf's up." I didn't answer. "Say it, Eddie," Louis went on. "Say all you need is some tasty waves and a cool buzz."

"All you need is to shut your fucking hole," my cousin George threw in. Not hostile, though. This wasn't a hostile scene at this point. Small town, working class. It's just the way we talk.

Louis didn't come back on George, though. He stuck with me. I was kind of the outsider of the house. Five of us lived there, and the other four had grown up together. We'd all be sitting around sometimes when George would cut on Louis for kicking Louis's ass in the first grade, or they'd talk about how they were all eventually deflowered by Mary Policcichio in junior high, that kind of shit. So when they needed someone to rag, it was only right for them to look outside the circle. And I took it pretty well. It didn't mean shit to me. Louis would be ragging me one minute and buying me a beer the next. Like I said, man, working class.

So I let Louis keep it up a little longer with his, "I know that dude," and "Learning about Cuba, Eddie? Having some food?" I just kept smiling and nodding until George pointed out that we were about to run out of whiskey. Everyone scattered into bedrooms and came out with beer mugs and Tupperware containers full of loose change, but not enough, so Richard, who was another of my roommates, and I split to drive around town until we could find some poor bastard stuck in the snow to pay for a bottle.

Mission accomplished in about twenty minutes. We got back to the place with a one-seven-five of drugstore brown whiskey (they don't even call it bourbon), a couple of bottles of RC, and a tray of frozen

lasagna. *Fast Times* was still on, just before the dance scene. I had the booze in my right hand and the bottles of soda in my left. Louis sat completely across the room, a basketball at his feet. Richard told the story of the housewife with a trunk full of groceries who was so happy that we'd pulled her car out of the snow that she gave us thirty bucks and the tray of lasagna. George and my last roommate, Rocky, threw up high fives to Richard.

Louis, though, threw the basketball across the room, nailing me in the head. "That's your skull, Eddie. You're so fucking stoned."

I put the bottles on the floor and said, "That's enough of your shit."

Louis looked at me with a grin full of teeth and said, "Be cool, Eddie. Be cool."

"Don't mock me, motherfucker," I said. "I'll throw down." And so on. Back and forth, me and Louis, with all that same shit that everyone says when they're trying to decide whether or not they really want to throw arms. During this time, Rocky snuck off to his room.

He came back out with two pairs of boxing gloves and headgear, screaming, "We settle this like men!" Obviously, the thought of scrapping Louis had crossed Rocky's mind before. Probably when Louis was ragging his Spanish ass during the inquisition scene of *History of the World, Part 1.*

I went back to my room to get ready. Louis did the same, and everyone else went into the backyard with snow shovels to dig out a ring.

Louis was bigger than me, a good thirty pounds heavier and two inches taller, so I decided to go with a little head game. I took off my jeans and black leather jacket and put on turquoise and green baggies with a floral design on them over my long johns. I also put on a surf shop t-shirt and my snow boots. Motherfucker wants a surfer, I'll give him a surfer.

My other roommates had dug a ten foot square out of the snow, with a border of snow about four feet high on three sides. They had three lawn chairs set up on the fourth side. They sat there, passing both bottles down the line and back again. Louis stood in the middle of the ring, gloves and headgear already on, punching his hands together. He saw my outfit and said, "What a fucking clown."

I tied on my gloves and headgear and walked into the ring with

him. Rocky followed me.

"All right," Rocky said. "No kicking no biting no scratching no hair pulling no shot to the balls no rabbit punches no TKOs. The only way we have a winner is if the loser cries 'Uncle.' Now go to your corners and come out scrapping."

Like I said, Louis was quite a bit bigger than me, but he came out flat-footed. Throwing arms like he wanted to lay me out in one punch. So I played defense, letting him punch the shit out of my forearms. I could hear George screaming for me, and Richard and Rocky cracking jokes about me getting my ass kicked. As soon as I heard Louis breathe heavy, I started working him low, throwing body shots, hitting his ribs. Louis didn't know how to face this. The only fights he'd been in were the ones where you try to knock the man down right away, go for the nose or the chin, then literally kick him when he's down. Or the ones where you try to get inside, get your hands on his inner thigh and neck, and flip him. But no one thinks to throw a body shot in a real fight, so Louis had never thought about how to block one. I kept catching his wind, and every time I did, I went high. Usually with a left-handed jab, so when I threw my big rights, they landed square. Pretty soon, I could see Louis's arms getting heavy from all those haymakers he threw to start off with. I was able to get a full-on, wound-up right across his jaw, and he went down.

Rocky didn't come back into the ring to ref, so I didn't go back to my corner. I just did an Ali dance over Louis. Every time he tried to stand, I tagged him in the head, saying, "Cry Uncle, motherfucker." Until, finally, face down in the snow, Louis said, "Uncle, motherfucker."

And thank god that he did when he did, because I was beat tired, cold, and losing my buzz. I went straight into the house to put on some warm clothes and fix a cocktail. By the time I got out of my bedroom and into the common area, two shots of Yukon Jack were poured, and Louis was waiting for me. The Yukon Jack was sacred. Louis, George, and I had stolen it from a yuppie bar one night in a drunken rage that we later rationalized as class war. Since then, the presence of the bottle had developed an aura in the freezer that demanded it not be touched until some unspecified special occasion presented itself. The very presence of it convinced me that all was forgiven, and Louis and I were seeing eye to eye again.

"Come on, Spicoli. Do a shot with me," he said. I walked over to

him and lifted a glass. He lifted his and said, "You kicked my ass good."

"Nah," I said. "I just come from a fuck, fight, or drink town. It don't mean shit."

We toasted, drank, and settled in for the encore presentation of *The Deer Hunter.*

The sun came out the next day. Spirits lifted. It was Saturday, so still none of us had to work. We drove into town and hung around for a while checking out boxing equipment at a sporting goods store. Then, we went to see if the video store had any cool flicks on sale, had lunch at an all-you-can-eat Mexican restaurant, and caught happy hour at Dugan's. We spent the rest of the evening shooting pool at the Thirsty Turtle. A few local chicks had come out of hibernation, too, so we had our first chance in a couple of weeks to hit on women. And all night, Rocky kept talking about the fight. Louis and I didn't add anything. We were both over it. But Rocky kept it up. Every time he'd line up for a shot at pool, he'd say, "I'm going to drop this ball like it's Louis." Or something to that effect. By the end of the night, we all knew the gloves were coming on.

Louis took Rocky. His second haymaker. He caught Rocky off guard and dropped him.

The next day, George and Richard got into a dispute over who was going to clean the kitchen and settled it with the gloves. George took Richard with a lucky shot to the temple. But rather than just clean the kitchen, Richard challenged Rocky, figuring, why clean when I can kick Rocky's ass. Which Richard did. So for the next two days, Rocky had to clean the whole house. Louis didn't think it was right, so he went after Richard. Richard dropped Louis, so Louis had to do Richard's laundry. George wanted his laundry done, too, so he took on Louis, but Louis won that one, so George had to wash clothes for Louis and Richard, which George didn't like at all, so he took on Rocky, won, and Rocky did everyone's wash in the house but mine. I didn't want any part of the insanity. I stayed out of it as long as I could. My big problem, though, was the list on the refrigerator. The rankings. Rocky was number five. He'd lost to everyone but me. George was four, although he'd beat Richard, because he'd lost to Louis and Richard had

beaten Louis. Also, Richard was the guy who ranked everybody. Louis was three, Richard two, and I was number one. And someone had to be eyeing that title bout.

Then the snow came back. All of us out of work again. Louis's girlfriend still had a flare up, so she'd bought a bunch of pornos for Louis, telling him to work it out for himself. By the third day of snow, we'd exhausted everything else and had the porno marathon. We'd also been forced to the cheapest liquor that the A&P carried: Sunset Tequila. No chaser. Maybe a lick of salt now and then, but that was it.

And after four hours of five guys sitting around, drinking what tasted like paint thinner and watching what looked like everyone else in the world having sex, I knew a bout was coming on. Richard challenged me. He hit me with a slew of Spicoli jokes, but I'd been the champ for the better part of two weeks and had grown immune to voice cracks. I just said, "You ain't a contender yet, Dick. You still haven't beat George."

George was passed out on the old, thrift store, Archie-Bunker-looking armchair. Richard slapped him in the face a couple of times to wake him up, then challenged him. George raised his head, opened his eyes just enough to see through them, and said, "What the fuck. I'll kick your ass again."

George borrowed a pair of my baggies for good luck and strutted into the ring wearing only the baggies, snow boots, gloves, and headgear. "Only way to stay awake," he said, but his eyes still hadn't opened all the way. I pulled him back inside and gave him some pointers: showed him where to hold his arms, told him to dance around, covering his face for the first thirty seconds or so, just until the blood started pumping, and told him the secret of the body shot. But George went back into the ring to fight his own fight. And Richard came out swinging. George just didn't have the defense. He went for a few big punches to the head, but they were slow and Richard wasn't having any. It took about five minutes for Richard to drop George. Then it was my turn.

I'd noticed that Richard held his arms low when he boxed, so I kept mine high, sending left-handed jabs to his head, using my right arm to guard my midsection. My jabs weren't hard. More of a lead in to the big right than an attempt to hurt him. But Richard caught on quick and with every jab I sent, he sent a right right over it, catching me in the head. But at the end, the weak point of his punch. So I faked a left,

drawing out his big right, ducked the punch, and caught him with an uppercut to the ribs. This knocked the wind out of him, so I delivered a Louis-style haymaker to his temple, and he dropped. And once you dropped in this ring, you didn't get back up.

At this point, the tequila reminded me that I descended from a hot-blooded Mexican grandfather. I took another shot, saw that the bottle had only one more shot left, finished the bottle, threw it against the side of the house, and screamed, "Can no man take me?"

This reminded George that he descended from a hot-blooded Mexican great-uncle, and he rose to the challenge. He was still half asleep and sluggish, though, and I took him before he hit anything but my forearms. Then Rocky saw his chance for redemption, to rise above household chores, but it took me about three blows to show Rocky why he was staying at the bottom. Only Louis remained, but he didn't want any. He knew he could only win with the big right, and he wasn't going to land the big right on me. "To the bottle of Yukon, then," I said.

"Not me," Louis said. "I'm going to my girlfriend's. She's gotta be thinking by now that I only go to see her to have sex." He headed for his car. I offered him my truck so that he wouldn't have to worry about getting stuck in the snow, but he turned it down.

Rocky turned down the shot, too. He said that he had laundry to do. George said he was going to pass back out. Richard did a shot with me. He didn't say a word—just swallowed an ounce and a half of the sacred Yukon, patted me on the back, and went into his bedroom. I sat around the common room, watching the tube, wishing someone would drink with me, but no one did. I put on *Fast Times*, but that didn't bait them. I fell asleep, woke up, went back into George's room and tried to talk him into another bottle, my treat, but he wasn't into it. I tried Richard, but he told me to drink my fucking Yukon. Rocky kept thinking that everything I said to him was a condescension. I waited for Louis. He started everything. At least he should drink with me. I sat up, drinking Yukon, waiting for Louis, but he didn't come home. I even drove into town and picked up *Stripes* from the video store, thinking, these guys can't sit in their rooms and sulk when *Stripes* is on. But they did.

Finally, I quit drinking the Yukon, put the bottle back in the freezer, turned off the tube, and headed for bed.

The funny thing about it, I thought, is that I can't even fight. Not in a real sense. Not in a barroom brawl sense, in a hit-a-man-out-of-

anger sense. Not when the other guy can kick and bite and pull hair and pull out a knife or a gun. Not when it has to be settled by taking every blow and swallowing blood until someone is crazy or brave enough to step in and break it up, or until the cops show, or until one guy hits the ground and he just can't get back up and the other guy kicks him until he's tired of kicking. Really, they all just fell for the same move. Body shots they didn't expect and left jabs. Left jabs they could have let me throw all day without any pain except in my left arm. Then a big right to the ribs and a big right to the head. Low then high. Every time. I just threw them off balance.

Nowhere, Alabama

I've always wanted to spend a few days by myself in a really small town in the middle of nowhere, where I know absolutely no one. When my truck's transmission blew outside Winfield, Alabama, I finally got my chance.

It was about nine-thirty at night and I'd been driving through the back roads of Alabama for about an hour and a half. As I got further away from Birmingham, the roads got less crowded, the forest around me grew more dense, and each town I passed seemed a little smaller than the one before it. It was kind of eerie—deep South after dark and all. I had a Dillinger Four album in the stereo, though, and that seemed to ward off evil spirits. I turned it up until the speakers rattled the door, and I screamed along and scared off the ghosts of the South and everything seemed right. The deep South seemed to be mine for the first five songs. Then, one of the songs grinded like I'd never heard it do before and my truck popped out of fifth gear. Luckily, I'd just hit the smallest of the towns that line State Road 78. I pulled into a gas station, popped the hood of my car, looked around, looked under the car, scratched my head, decided that the whole problem was a figment of my imagination and that the best way to fix it was to ignore it and keep driving. When I put the truck in first gear, it grinded and popped again, but this time the radio was off. The problem wasn't in my head and I couldn't blame it on D4. Fuck, I thought, why do the worst things always happen during the best albums? I tried second gear, and it worked fine. Third gear worked, too. I drove about a mile across the tiny Alabama town and found the Rainbow Hotel before I could try fourth gear.

Obviously, the problem was my transmission. I knew this. I knew that I couldn't ignore it and hope it would go away. I knew I couldn't drive with it until I got some place where I knew someone—I was on my way west to California and my closest friends were several hundred miles back east, in Atlanta. I knew, basically, that I was going to spend a few days in that town and leave most of my money there and there

was nothing I could do about it. So why fight it, right? It's like Ghost Dog says, if you're hit with a sudden rainstorm, the best thing to do is resolve yourself to getting wet.

The next morning, I talked to the guy who ran the hotel and he recommended a transmission guy on the other side of town. "Sorry I don't know anyone closer than that," the motel guy told me. "I'd hate for you to drive all that way."

"That's okay," I said, because I knew it was only two miles to the other side of town.

I called the mechanic. He told me to bring my truck down and see if it really was the transmission. I knew it was. He knew it was. There are no simple transmission problems. Either you have gears to turn the axles of your car or you don't. Still, I drove it down and he took a look at it and he said, "Yep. We're gonna have to rebuild it. Can't do it till tomorrow." Which was fair enough. I couldn't expect him to stop everything he was doing to focus on a stranger's truck, and I wouldn't have wanted to go to a mechanic who went to work in the morning with nothing to work on unless a stranger with a bum tranny limped into town. Still, it hurt. He also gave me an estimate that was less than I expected. Still, that hurt, too. Then, he apologized for making me drive all the way across town just for him to tell me that.

"That's okay," I said. And since I had all day with nothing to do, I asked him, "What is there to do in this town?"

"Nothing," he said. "Relax."

I went back to my hotel room to feel sorry for myself.

Feeling sorry for myself was boring, though, so I tried to convince myself that a few days in Winfield was exactly what I wanted, that I'd always wanted it, in fact. I tried to pull the old Jedi mind trick, wave my hand across my face and say, "These *are* the droids you're looking for," and find a Millennium Falcon in this backwoods spaceport. And the strange thing was, I did. In a manner of speaking, anyway.

The hotel was essentially a six bedroom house. Every room had a bed and a desk and a TV. There were two communal bathrooms, a kitchen, and a living room. I think the proprietors lived in the house behind the hotel, but they seemed to spend all their time watching TV in the motel living room. As I headed out of my room to check out the town, I waved to the guy who ran the hotel. "Where are you off to in such a hurry?" he asked. I realized I wasn't off to anywhere, really, and sat down to chat with him. He asked me about my truck and where I was from and where I was going and what I did for a living and things

like that. I answered all his questions, but when I tried to ask him something about himself, he said, "Well, I don't want to keep you any longer."

I took the hint, but since I still didn't know what to do with myself, I asked, "What is there to do in this town?"

"Nothing," he said. "Relax."

There must be something, I thought. This is a hotel. People must come through this town and stay at this hotel on purpose. What do they do? So I asked, "What do most of the people who stay here do?"

"Visit folks in the hospital," he said.

It didn't make any sense to me until I walked outside and saw a hospital directly across the street. I wasn't about to visit anyone in there, so I walked downhill for about a half mile and hit the downtown area.

The downtown was only a couple of blocks, all old brick buildings in pretty good shape, but not in a renovated-to-have-a-quaint-downtown-shopping-area way. The downtown clearly had been the only place to buy any goods for a long time. There was a bank and a hardware store and a drugstore and a bunch of empty shops. Not completely empty shops. Most of them still had shelves in them, or desks, or cash registers, or scattered pieces of merchandise that would never sell. Most of them had rental signs saying, "This building is not empty. It's full of opportunity." No one walked around downtown but me.

Railroad tracks bordered downtown to the south. Four different trains came through over the course of an hour. None stopped. None even slowed down. They just charged through with their whistles hollering. There were a bunch of warehouses along the tracks, but no one seemed to be working in any of them. No one seemed to be around at all. Plenty of cars rolled down State Road 78, which bordered downtown to the north, but, like the trains, none of them seemed to stop. The traffic was mostly just eighteen wheelers cutting across from Interstate 20 to Interstate 40, just like I'd been doing. There was something weird about this town. Something had happened. Something had changed.

I kept wandering around, determined to find some people. I finally reached a diner that had "Bringing back the rock and roll" painted on its front window and actual people inside and forty-fives hanging from the ceiling and pictures of Elvis and Marilyn Monroe on the wall. I went inside and ordered some grub and asked the lady behind the counter, "If

you only had two days to see this town, what would you do?"

"Nothing," she said. "Relax."

I couldn't take it. There had to be something to do. There had to be someone cool to meet or somewhere cool to go. It was just a matter of finding it. After lunch, I walked up and down every street I could find. I smiled and made eye contact with everyone on the street. I looked everywhere I could for some kids skateboarding or shooting hoops or something. I listened for music from passing cars or houses I passed. My head started to get really cold, so I went into a dollar store and bought a stocking cap and tried to spark up a conversation with two different employees. I went into a grocery store and chatted with the guy behind the counter for ten minutes. I paced around downtown until I started feeling like I might get arrested for vagrancy, then went back to the motel. For the rest of the night, I read and watched TV and wrote two sad letters to my girlfriend and did nothing. But I didn't relax.

The next day, I drove my truck down to the mechanic's shop. They took out my transmission and went to work on it. My plan was to drive the truck to the shop and walk back to the motel room, but it started to rain before I started to walk, and it was about thirty-five degrees outside, so I decided to hang out and wait. It rained through one hundred and fifty pages of a Raymond Chandler novel and three zines. And it kept raining. I hoped the temperature would drop a little and the rain would turn to snow, which I could walk in. I read two *Field and Streams* and a *Popular Science*. And it kept raining. With nothing left to read and no TV to watch and no one to talk to and nowhere to go, I just watched the mechanic rebuild my transmission. I watched him take every piece off individually. I watched him clean each piece thoroughly with a wire brush, disassemble and reassemble that massive, complex, intricate piece of machinery and make it seem so simple. As I was watching him, the owner of the shop walked through the waiting room, said hello to me, grabbed something from behind the counter, and left. It's funny, I thought, that they'll let me sit here and watch them work on my car. I thought the first rule of auto mechanics was to never let the customer see you work. These guys, though, had invited me back into the shop a few times. They showed me my transmission and explained to me how they'd fix it. They even showed me the transmission they were taking apart to rebuild mine. I thought about all of this and thought, could you imagine AAMCO doing that?

And that's when it struck me. This wasn't AAMCO. The owner's last name was on the sign out front. His home phone number was listed

in the phone book right above the number for his shop. I started to piece together the day before. When I'd gone into the grocery store earlier, it was Ivey's Market and the guy I chatted with was named Ivey. The dollar store I'd gone into wasn't a Dollar General. It was Paul's Dollar Store, or something like that. The diner was Burgers-n-More, not Denny's and, in fact, I didn't see a McDonald's, Burger King, Taco Bell, or any fast food joint at all. As my mind traveled back up and down the two mile stretch of Winfield, Alabama, I realized that I hadn't seen one single chain or franchise store. Even the banks were community banks. Even the gas station I stopped in that first night had someone's last name on the glowing sign. Every establishment I could think of was locally owned. Almost all the money spent in Winfield stayed in Winfield.

Then, I thought of my hometown, which isn't a small town. Just a small-minded one. There's one spot in my hometown where, on one side of the road, within a half mile, there is an Applebee's, a Steak & Shake, a Hooters, a Barnes & Noble, a Toys-R-Us, a Smoothie King, a Burger King, a Blockbuster, a Chili's, and an Office Depot. Across the street is a Walgreen's, a First Union, a Firestone Tires, an Outback, an AMC Theaters, and a mall. And if there is any major chain that didn't make it into that square half mile, you could go a half mile in either direction (between the Wal-Mart and the Bank of America) and find it. And none of it was there ten years ago. A town that was once cool and had an identity of its own, where people had a chance to own their own business and know that, when they purchased something, the money went to their neighbors, has been completely taken over by national and multinational corporations. I hate it. If my parents didn't live there, I'd never go there again. It's become a generic town. The main road of that town is exactly like the main road in Flagstaff and some street I drove down in Vegas and most places in the US right now. There's a good chance that you could read that description of my hometown and wonder if you're from the same place.

But there I was, in the middle of nowhere, Alabama, and I finally found a place without a McDonald's. Fucking-A. I watched that guy fix my transmission and watched the rain fall on the red Alabama clay that streaked the hills and I thought, damn, I like this place. I thought about Azrael from the movie *Dogma*, who'd rather wipe out existence than exist in hell. I wondered, would I rather live in a town with nothing to do but nothing I hate, or would I rather live in a city filled with a thousand choices of things to do, but nowhere to put your money

besides Bank of America? Then I started to daydream. Could I actually move to a town like this? Would it be so bad? Maybe I could open a punk club in one of the stores or warehouses downtown—rent had to be cheap and there was no one around to complain about the noise. Kids around here had to be bored and full of angst. They could probably help me convince the city council to build a skate park. Then, if I could just somehow convince my girlfriend to move here, I'd have all I needed right here in the hills and forests of Winfield. And if I really needed a city that badly, I could always drive the two hours southeast to Birmingham or the two hours northwest to Tupelo, Mississippi. How bad could it be?

Then, I listened to myself for a second and had to look at my reflection in the window, just to make sure it was really me having these thoughts.

About that time, another guy came into the waiting room. His transmission had just gone out on him. He'd gotten a tow to the shop and was waiting for his daughter to pick him up. I noticed he didn't have a southern accent and asked him why not and this entitled me, apparently, to his life story. Which was fine with me. I had time to listen.

He told me that he'd moved down from Michigan in the seventies. He'd worked in the auto industry in Detroit until the auto industry there went into a slump. After Ford laid him off, he found a job in a plant in Winfield manufacturing some kind of part for some piece of heavy machinery. After twenty-five years, he retired and was now doing nothing. Relaxing. He seemed pretty satisfied.

I asked him if he'd been in a union while he worked at the plant. He told me that he'd been an administrator, so he didn't need to be in a union. "But you shouldn't knock unions," he said, even though I wasn't knocking them, and he's probably never met anyone more pro-union than me. "Even when you're not in it, the union makes everyone's life a little better," he said. And with that, the old guy made a friend.

We talked more and he told me that the unions couldn't save Winfield, that there was a 3M plant north of town that was moving most of its manufacturing to Mexico. The plant where he'd worked had already pretty much downsized itself into oblivion. It was kind of like Michael Moore's Flint or seventies Detroit all over again. I asked if that was why all the stores downtown had closed. "No," he said. "That happened when the Wal-Mart opened up in Guin, about ten miles up the road."

Glue and Ink Rebellion

"That's too bad," I said.

"Nah. I like Wal-Mart," he said. "You don't have to run around so much. You can get everything in one place." And with that, he almost lost a friend.

I wanted to explain to him about Wal-Mart, how Wal-Mart uses all its money and lobbyists and senators to push through NAFTA and support the domination of the WTO so that Wal-Mart could get all its shit from sweatshops. And, by doing that, they bypass the cost of labor, more or less, and take away jobs that would've stayed in America. Then, they lower their prices only enough to run the independents out of business. This creates the monopoly which allows them to raise the prices again. I wanted to explain that Wal-Mart was exactly the kind of business that paved the road that his old manufacturing plant took to Mexico. That Wal-Mart is exactly the kind of thing that killed my hometown and would kill Winfield. The more I thought about it, though, the more futile it seemed to explain this to him. It would be like trying to get a guy dying of emphysema to quit smoking. Because you know that he already smoked the cigarette that killed him.

It took another day for the mechanic to finish rebuilding my transmission. He cut me a good deal even though he had nothing to gain by it, and I felt relieved that, if the transmission had to die, it died where it did. I drove northwest out of Winfield, towards Tupelo and Memphis and the rest of middle America. Before I'd gotten a mile north of the motel, I passed a dozen fast food joints and assorted national chains. The Dillinger Four album had picked up where it left off when the tranny had dropped, though, so I turned it up until it shook the doors, and I screamed along and hoped the music would scare off big business. And though I left most of my money and three days of my life in Winfield, I felt kind of good. Because even though it's a place I could never live in—and don't even really want to visit again—it was still really cool to be in a town that was poor and forgotten enough that big business wouldn't touch it, but not so poor and forgotten that they couldn't just do nothing and relax.

Brandon's Posse

Brandon's Posse

The band was taking a long time between songs and the pit was still swirling down by the stage. I grabbed a beer from the cooler, gave it to the guy who ordered it, took his money, and gave him change. The whole time, I was waiting for the band to play another song. But they didn't. They didn't tune their instruments or talk into the microphone or anything. The pit kept moving. People crowded into a tight mass around it. A fight, I thought. I looked for the security guy over by the front door. He wasn't there. He wasn't anywhere in the bar. I was sure of that. A six-foot-four, steroid-driven black guy is easy to pick out of a suburban punk crowd. I looked at the sound guy. He clearly wasn't gonna do anything. The only other person working that night was the door lady, but she weighed well over three hundred pounds and got winded walking to the bathroom. Shit. It was up to me to break up this fight.

I locked the cash register, emptied the tip jar, put the money in my pocket, and walked across the dance floor. The closer I got to the fight, the tighter the crowd around it was. I pushed my way through and saw, luckily, that it was just two small guys, both of them probably too young to be in this bar in the first place. I stepped between them, grabbed them both by the collars, and held them at arm's length away from me and each other. "That's it, fuckers," I said. "You're outta here." The kid on my right swung a few punches at me. His arms weren't as long as mine, though, and his punches didn't reach my body. It was kind of funny. I laughed inside at the absurdity of it: a trick from the *Little Rascals* was working in a bar fight. Before I could laugh out loud or drag either of the kids very far, someone sucker punched the kid I held with my right hand. I turned to see who it was. Just then, someone tackled the kid I held with my left hand. The kid I'd held with my left hand and the guy who tackled him flew up onto a table. Goddamn it. This wasn't funny. I made my living off of those tables. On more civilized nights, people sat there and ate food and drank beer and tipped me money. If that table was broken, the little money I made became a

little less. I grabbed the guy on top, put him in a full nelson, and pulled him off the kid he tackled. I started to push the kid in the full nelson towards the door when someone kicked him. Jesus Christ, I thought, what's going on here? I looked up and saw fights breaking out in concentric circles around me. A full-on barroom brawl. And I was the only guy working in the bar. And I was standing right in the middle of it. Fuck.

I let go of the kid in my hands and started to work my way towards the stage. Everywhere I looked, people were fighting. Indiscriminately throwing punches and swinging chairs and breaking beer bottles. At least three beer bottles flew past my head. Someone punched me. I turned and saw a girl with long bangs and a buzzed head. She looked to be about nineteen or twenty and was holding her fists up at me and snarling through jagged teeth. I looked at her and thought, you've got to be kidding me. At least three times during every shift I work, I throw around kegs of beer that weigh more than you. She swung again. I dodged it, said, "Cut it out," and kept making my way to the stage.

By the time I got there, the band had cleared out. I stepped up to the microphone and yelled, "Everyone get the fuck out. Show's over. Go home." About this time, the house lights came on. The sound guy turned on his microphone and started screaming about having a gun and wanting to shoot every last motherfucker in the room. I also noticed the six-foot-four, steroid-driven security guy. He was pushing kids out the door one at a time. I jumped back down on the floor and started kicking people out, too. I wasn't hostile or mean about it. I didn't hit anyone or try to hurt anyone. I just tried to clear the room.

It was tough. Most people were still fighting. I'd see comical things. A guy tried to punch a girl, and when I saw him wind up, I picked up the girl and pulled her away. The guy hit nothing but air. The girl kicked me in the shin. I saw people slapping other people. Open handed. In a real fight. I couldn't believe it. Suburban kids at a punk show.

It took about ten minutes for the security guy and me to clear out the room. It would've only taken about five, but the band kept letting people back in through the back door. Finally, I threw all five members of the band out and locked the door behind them. They banged on the door and screamed something about needing to get their equipment. I told them to wait ten minutes. Then, suddenly, everything was silent.

I looked around the bar. The door lady sat in her chair, looking

really scared and confused. The sound guy still stood behind the sound board. The security guy stood next to me. We were both breathing heavy. And the rest of the room was empty. Well, completely trashed. Broken chairs. Broken tables. Broken bottles on the floor. The cooler was open from where someone had capitalized on the chaos to steal some beers. Posters and fliers were torn off the walls. But no people. I smiled. The security guy asked me what happened. "A fight," I said.

"No shit?" he said.

I laughed, relieved that the worst of it was behind me. "Yeah," I said. "No shit." I thought about asking him where he'd been, but I knew. A sorority from Spelman College was having a party next door. He'd been over there hitting on those girls most of the night. Anyway, it didn't matter. Everything was over. All the brawlers were out on the street, where they could beat each other senseless, for all I cared, as long as they didn't involve me. What did involve me was the band. They kept banging on the door and bitching. Finally, I opened the door and said, "Will you quit fucking knocking? Do you think I'm gonna pawn your shit in the next ten minutes? Give it..."

Before I could say anything more, I heard a scream from the parking lot. It was one of those screams that tattoos itself into your brain with its shrill desperation, one of those screams that carries with it the sense that whoever let it out believes that her life has changed for the worse because of what she's just seen. The security guy and I ran outside.

About ten people were crowded around a silver Honda hatchback, rocking it like they were trying to tip it over. People behind them were throwing rocks at either the car or at the people trying to tip the car. Either way, rocks pelted both of them. One guy managed to get the door open and attacked the driver. The driver responded to this by throwing the car in reverse and slamming into the sound guy's truck. Then the driver shifted back into first and took off. He didn't seem to care about the crowd in front of him or the guy hanging on to the driver side door, punching him. The car hit Marietta Street going about fifteen miles an hour. The dude hanging on to the door dropped, rolled five or six times, popped back up, and ran down the street after the car.

I looked back to where the car had been. The crowd was still there, but no longer fighting. The girls cried. The guys talked of killing the dude in the car. I walked over and suddenly saw why ten men tried to take on a car. The driver of the car had evidently run over (not hit; run over) one of their friends. About twenty-five feet from the front door of

the bar, a guy was lying face down in the street. His hair was matted with blood just starting to coagulate. Fresh blood trickled out of his nose and mouth and collected like a spilled pint of Guinness on the pavement. The guy's name must've been Brandon because one of his friends told him, "Hang on, Brandon. You gotta stay alive long enough to see me kill that motherfucker who did this to you." None of the kids tried to call an ambulance. None of them tried to help Brandon. They just swore revenge.

I looked across the guy bleeding on the street and into the faces of his friends. They all wore their punk uniforms: spiked belts, Pennywise hoodies, Black Flag patches. The street lamp cast a dull glow on their faces, enough for me to see no scars. No cuts. Nothing. This was probably the first time most of them had been in a fight in their lives. "We'll kill that motherfucker for you, Brandon" rang in my ears. I couldn't picture it. Guys named Brandon don't have a posse. Friends of Brandons don't get into wars with Cobb County kids in Honda hatchbacks. This was still all pretend for these kids. Even in the face of it, even with their friend lying face down on the street with a tire mark across his back, it was still all a game. A TV show.

A few minutes later, the cops showed up. The ambulance was right behind them. The security guy had radioed for them. At first, it scared me. I was standing outside of a bar where I was the only bartender, watching an underage drunk kid bleeding heavily, surrounded by a dozen of his underage friends, all of whom were drunk. And who served them the booze that got them drunk? Me? Well, I hadn't served the kid on the ground. He'd shown up wasted and didn't have a fake ID, so no. I hadn't served him. I'd even kicked him out of the bar earlier that night. Twice. So I was in the clear there. The rest of the kids, yeah. I served them. Yeah, I knew they were underage. Yeah, they all had horrible fake IDs. But a legal drinking age is a bad law and, as a rule, I don't obey laws I don't agree with. And, yeah, you could argue that possibly the whole barroom brawl started because I served a bunch of underage kids. You could also argue that, if the kids had been allowed to drink at a younger age, they would've learned how to handle their booze before they started going to bars, and they never would've started a barroom brawl to begin with.

Anyway, there I was, faced with the possible consequences of my civil disobedience. Then I remembered that the reason the security guy was able to radio the cops instead of call them was that he was a cop. An off-duty cop, but a cop just the same. And the reason the police and

ambulance actually showed up to this part of town after midnight was that we paid the cops two hundred bucks a week to "protect" us. So I stopped worrying about myself and started worrying more about the kid who may or may not have been bleeding to death on the ground in front of me.

What made me worry most about the kid was the writing on the ambulance: Grady Hospital. The worst place in the world for a sick or injured person. And the Grady paramedics showed why that was true. The two paramedics ran up to the kid. They set the stretcher on the ground next to him. One paramedic had a neck brace in her hand. She set that on the ground, too. She looked at the kid. He really did have a tire track across his back. He really had been run over (not hit; run over) by a car. The paramedic pushed the neck brace aside and grabbed the kid's shoulders. The other paramedic grabbed the kid's feet. They flipped him on his back. His head flopped like it was connected to his body by a slinky. The paramedics picked him up and ran him over to the ambulance. Then, they drove off. The cops didn't ask questions of anyone. A news van showed up. A young woman and a camera man tried to get out and get some footage of the scene. A police officer hardly even let them step out of the news van before he turned them around and sent them on their way. Good to know that the two hundred bucks a week really did get us some protection. I guess cops are like the Mafia—not so bad when you can afford to pay them off.

The next day, it poured rain. I showed up for the lunch shift at eleven o'clock. By then, the floors had been hosed down and the tables and chairs were standing again. One of the neighborhood crackheads who got paid twenty bucks to clean up after punk shows was there. He looked exhausted. He'd earned his money that morning. My boss was there, too. He looked nervous. "Did you hear anything about the kid?" I asked him.

My boss shook his head. "It's pretty bad, huh?" he asked. I nodded. "Do you think he's gonna die?" my boss asked.

"Yes," I said. Even in the pouring rain of that morning, I had still seen the blood stain on the pavement outside the bar. I couldn't imagine anyone losing that much blood and living. Especially after a trip to Grady.

My boss nodded and went back into the kitchen. We didn't talk about it any more.

The lunch shift went by pretty quickly. It was a Monday, after all.

By two o'clock, lunch was over and I was done working until the next show that night. I left the bar, took a couple of steps in the rain, and stopped at the blood stain. Three hours of a downpour and an occasional car had scrubbed most of the blood away. I squatted down in the middle of the street, feeling the rain pummel my back and saturate my shirt. I stared at the red stain on the pavement. I watched the rain drops pound it. I don't remember thinking about anything.

For the next few days, I thought about that kid a lot. I'd catch myself occasionally seeing his face when I blinked. I'd hear that girl scream in the background of songs. I didn't know how to react. How could I? The event had come and gone. All hope for action was nestled in the past, and the past is a place I physically cannot go to. I thought about how I had acted and reacted. I tried to stop the fight. I stood back and let the paramedics and police do their jobs. The kid went to the hospital. Doctors did whatever they could do. That was that. I thought about the punk-uniformed friends of Brandon and their cries for vengeance, thought about how ridiculous they sounded. I knew they had no idea who the guy in the silver Honda was. What were they gonna do? Drive around Atlanta until they saw a silver Honda, then attack? That's absurd. So I went to work and served beer and food and watched bands play and went home and listened to music and hung out with friends. It rained a lot for the next week and the blood washed away.

I started to realize that the best I could do was to resolve myself to the fact that things happen that are beyond my control. Tragedies occur through no fault of my own; violence in the past, no matter how recent the past is, cannot be dealt with in the present. The best I can do is not engage in the violence myself and to try to stop it when I can.

Then, something else started to occur to me. It happened on my day off. I hopped a train and rode downtown to a bar where I used to work. One of my buddies was tending bar. He set me up with drinks. We talked about shit in general. While I sat there, a bunch of regulars came in and out. I knew most of them. All the members of the wait staff came over at one point or another. I chatted with them all. Happy Hour came and went. I wandered back to table 59—the employee hangout table. Three cooks sat there drinking their shift drinks. I hung out with them for a bit. One of the cooks and I decided to head out to the next bar, so we took the train to Little Five Points. On the train, I told the

cook about the barroom brawl. "That's some fucked up shit," he said. I nodded. He was right. He reacted the only way you could. I looked around the train at all of the people, and the sheer number of people dazzled me. Not the number of people on the train. Just the sheer number of people in the world. People I knew at the bar where I used to work. All of the people I served beer and food to. All of the people who came to all of the shows. All of the people on the train and in my neighborhood and in Atlanta in general who I'd pass on the street and nod to and smile, or talk to, or try to share a road with, or come in contact with in some way or another. All of the lives and all of the human drama that surrounded me. And I was just one of the billions. It was suddenly staggering—a moment of vertigo when I realized how meaningless a life can be and how callous and jaded I'd become trying to survive in a cruel and overcrowded world. More than anything, I wanted the train to be in Little Five Points. I wanted to walk across the field and up the hill to my apartment, to grab a beer and drink it really quickly and stop thinking. The train stopped at the Martin Luther King station. One away from my own. I told myself to relax, that life doesn't have to mean that much; it just has to be worth living. That a higher power doesn't have to be a god or a force of nature. It can be nothing more than a train that you're stuck on for another stop. I told myself that most things were out of my control, and it was okay. Who'd want the responsibility of controlling everything, anyway?

About a month later, a girl came up to my bar and ordered a wine cooler. She was clearly underage and handed me an ID even though I didn't ask to see one. I looked at it. It was supposed to be a Georgia Tech student ID. Georgia Tech was right down the road from where I worked. I knew what the real student ID looked like. This wasn't it. This was a very bad fake. It reminded me of the one my friends and I had made years earlier. We'd drawn a poster to look like the University of Maryland student ID, complete with a name, address, birth date, the state seal, everything. We hung the poster on the wall and all took turns getting our pictures taken in front of it, then laminated the pictures. It looked fake, but it worked all right. The only downfall was that all of my friends and I had the exact same fake ID. Only the faces were different. So I knew this kind of fake well, and I recognized the particular poster that this girl had used. It was the same ID that the kids had been using on the night of the barroom brawl. I handed it back to the girl, grabbed a wine cooler for her, took her money, gave her

change, and said, "You don't know Brandon, do you?"

"Do you know Brandon?" she asked.

"No."

"You were working that night when he got hit, weren't you?" she asked. I nodded. "That was a crazy night," she said.

I nodded again. "How is he? I mean, he isn't…"

"He's fucked up," she said. "His whole chest and back and right arm is in a cast, but he doesn't even care. I saw him last weekend. He was all drunk and trying to pick a fight."

I'd like to say that I was relieved that the kid didn't die, but I wasn't. I'd already mourned for him. I'd already dealt with the philosophical and emotional ramifications of someone bleeding to death at my feet. The fact that the kid lived didn't change any of that.

Two more weeks passed. My boss came up to me after a lunch shift and told me that the kid's mother was suing the bar. I should've seen that coming. That's the real way that a Brandon's posse fights back. The next couple of weeks, my boss didn't pay me. He said that the lawyer was taking all of his money. "When the insurance money kicks in," my boss said, "I'll have enough money to pay you." But that never happened. Because I liked working at that bar and because most of my money came from tips anyway, I worked there for about two more weeks without getting paid. Finally, it got to me knowing that all of my money was going to lawyers and insurance companies and the suburbs. I found another job.

As I walked out of that club for the last time, crossing the street where the blood stain had completely washed away, the whole situation came to me with remarkable clarity. It was nothing more than random violence and a working man getting fucked in the end. At least things were back to normal.

Beauty Smacking Me Upside the Head

Beauty Smacking Me Upside the Head

I had beauty on the brain. I had to write an article on it for a magazine, and the deadline was coming up just about the time that spring was ending in central Florida and the long, steaming blanket of summer was descending. So yeah, I thought, a fleeting time of year surrounded by the stark contrast of the seasons when my hometown goes from paradise to oppressive. It was the perfect time to think about the concept of beauty, its fleeting nature and stark contrasts. I had to go to Merritt Island, about twelve miles away, and traffic where I was in Cocoa Beach was murder, so I decided to ride my bike. I figured that somewhere in the salty breeze blowing in from the Atlantic, somewhere in the path of my spinning bike tires, somewhere between the blue sky and the glassy calm water of the Banana River was something that would help me understand beauty. So I rode my bike and checked out the scenery and thought.

Coming down the high bridge on 520, I saw a man and a woman sitting on the sea wall of the park below. They each held fishing poles, and they held each other with their free hands. They looked to be straight out of a Norman Rockwell painting (in a fat, working-class Florida kind of way). Okay, I thought. There's definitely some beauty in that, in two people in love and free to sit and fish on a sea wall underneath a bridge, hoping to get a really good dinner out of it. I kept riding, down the bridge, past the park, over another bridge, and past a little hole in the wall of a bar. The bar's front doors were open, and the smell of cigarette smoke drifted out. Almost as soon as it hit my nose, I reached the fruit stand next to the bar, and the scent of fresh peaches replaced the stench of smoke. Okay, again, a little more beauty in contrast, in moving past the bad and into reward. Still, I felt like I was trying too hard to find beauty. I wanted something concrete, something to smack me in the head and say, "This is beauty." And, sure enough, I got smacked.

Just past the fruit stand was South Banana River Drive. The traffic on Banana River Drive stopped for a red light. The red hand on the

crosswalk sign disappeared and the white walking guy invited me across. A truck sat in the crosswalk waiting for the red light. Faced with the choice of riding my bike in front of the truck and into eastbound traffic on 520, or riding behind the truck and crossing Banana River Drive just behind the crosswalk, I chose the second. I whipped into Banana River Drive behind the truck just as a big Lincoln whipped off 520 and took a right hand turn into Banana River Drive. I saw him and jammed on my brakes. He saw me and jammed on his brakes. My bike skidded and his Lincoln skidded and I thought to myself, he's gonna stop on time. I'm gonna stop on time. It's gonna be fine. Then, all of the sudden, it wasn't fine. Nothing was fine.

Suddenly, my bike was twenty feet down the road, and I was in the air. I landed on my elbow on the hood of the Lincoln. The Lincoln screeched forward. I rolled onto my back and my head slammed into the windshield and my feet flew past in a way I'm just not limber enough to pull off. The car finally stopped. I slid forward a little on the hood, but didn't hit the ground. Then it was over. I lay on the hood for a second and wondered if I was still alive and if I would ever walk again. That second passed, and I realized that I really wasn't in that much pain. My elbow hurt, sure. I'd landed pretty hard on that hood, but I weigh two hundred pounds. There are no soft landings for me. My ankle hurt from where the crossbar of my bike had hit it after the car had hit my bike, but I could tell that my ankle wasn't broken. I decided to try standing. I found that I could still do it. I tried walking, and that was a piece of cake, too. I walked over and picked up my bike, walked another twenty feet and picked up my bike lock, then dragged them over to the side of the road. The old man driving the Lincoln stood there waiting for me.

The old man was an unattractive guy. No doubt. He had a yachting shirt on, unbuttoned all the way down, with his big belly hanging out. He had kind of a porcine nose and a big gap between his two front teeth and, even as shook up as I was, I could tell that he was wearing a rug. Still, there was something undoubtedly beautiful about him because he was clearly and genuinely concerned about my well-being. He apologized emphatically. He placed a gentle hand on my shoulder and looked me in the eye and offered to drive me to the hospital. He even asked if my bike was all right, but not once did I see him look at the hood of his own car. The whole time, too, he did all the things he shouldn't have done if he wanted to protect himself from a lawsuit. He admitted fault and pressed me to see a doctor (and he had to know, like

all people know, that a heavy guy who rides a Schwinn on a ninety-degree afternoon can't afford to see a doctor. It's the thin men on expensive bikes who get medical care in this country). I felt all right, though. I felt kind of good, in fact. And my bike was a little banged up, but the good thing about an old Schwinn mountain bike is that it's built to roll down a mountain without a scratch. I straightened the handlebars and the seat. I kicked the front tire back into place and fiddled with the front brake until it came unstuck, then rode off. I didn't even get the old man's name or give him mine.

Another mile down the road, I crossed another bridge, this one over Sykes Creek. By then, the initial shock of the accident had worn off and the pain had not yet set in. I felt like a real bad ass. I'd even begun daydreaming about being a Hollywood stunt man. Hell, I could roll off the hoods of Lincolns all day. When I got to this bridge, though, a Rastafarian-looking guy blocked my path. He pulled a cast net up from Sykes Creek. I stopped and waited for him to empty it and get out of my way. All along the walkway, seaweed rotted in the heat. The Rastafarian emptied his net onto the walkway. A half dozen mullet flopped out with a couple of jellyfish and more seaweed that would soon start rotting. I leaned on my handlebars and smelled the rotten seaweed and watched the guy pick up the mullet and dump them into his bucket of water. I listened to the fish splashing in the water of the bucket in their vain attempts for freedom. I thought of that one mullet who'd probably been right at the edge of the cast net. The weight of the net probably hit him in the head and dazed him. He must've panicked and swam left when all of his friends swam right. Now, six of his friends flopped to no avail in a bucket, and he swam around Sykes Creek with a sore head, sure, but still swimming. I thought of myself and my own sore head and felt glad to still be able to pedal. At this point, the day turned from a pretty one to a beautiful one. At this point, I finally understood something about beauty.

It's funny the things we talk about when we talk about beauty. In these times, in the United States, when we think of beauty, often anorexia comes up. The day before that old man drove his car into me, I'd gone to the library to try to get some ideas for the column I was writing. I'd noticed that several mass market, glossy magazines had articles on women like Calista Flockhart and Courtney Cox starving themselves to meet the image that Hollywood demands of them. Most of those articles made a reference to the idea that people were "dying for beauty." While it was true that people were dying for beauty, it had

nothing to do with Hollywood. No models or actresses were dying to become beautiful people. Most public figures weren't dying to make the world a better place or to redistribute wealth or to work for universal health care so that heavy guys on Schwinns could see a doctor after they got hit by a Lincoln. All I saw was actresses getting sick so that they could look like other actresses getting sick, and sick teenage girls getting sicker to look like these sick actresses. Some of them may have been moderately attractive, some may have been really pretty, but none of them came anywhere near beautiful. Not in a magazine layout, anyway. The people who were dying for beauty were the Yugoslavians standing in bomb zones with targets on their chests in protest of NATO bombs wiping out their hospitals; or the Lakota nation starving in South Dakota because they still refused to give in to the lifestyle of their captors; or the revolutionaries fighting for the Chiapas in Mexico. Dying for peace or so that others can live freely is dying for beauty. Dying of starvation when you have plenty of money to buy food is nothing more than being too stubborn to admit that you need help.

This brings us to the second thing we think about when we think about beauty, the old "truth is beauty, beauty is truth." What the hell does that mean, anyway? That the meaning of life is hidden in the gleam of a model's eye? Not fucking likely. It means that the two are inseparable. If there is no truth, there is no beauty. Beauty is an abstract. It is a moment when you finally see through the depths of life. It's a sentence, like when William Kennedy describes a Depression-era hobo camp as "a visual manifestation of the malaise of the age and the nation." Beauty is a well-timed moment, like when questions about how you're living your life get to be too much, and you're inches away from chucking it all and getting an office job, but instead you play a Tiltwheel album. You listen to the song "Manila" tell the story of a rebellious kid who turns into a rebellious adult and ends up laughing at the office drones in the end, singing, "How does it feel to die slowly?" again and again. And the music washes over you like a confirmation. Beauty is when you finally see one of Van Gogh's sunflowers and realize that the paint is an inch deep on the canvas, when the texture of the painting invites you into the artist's psyche. Beauty is when you smell your lover's bad breath and look at the crust of sleep in her eyes and your heart still races with love because she's learned to ignore the same things about you. Beauty is fat lovers fishing and fruit stand peaches and a Rastafarian with a bucketful of mullet. So you can binge and purge all you want, you can live your life on celery and Diet Pepsi,

you can spend all your money dressing just like *In Style* magazine tells you to, and all of this won't bring you any closer to becoming beautiful. It's only when you start to embrace truth that you become beautiful. And I'm not talking about meaning of life/Tibetan monk truth, here. I'm just talking about treating people with honesty and trying to understand what makes other people who they are. That's beauty. That gets us back to me and the old man and the Lincoln.

When I finally got off my bike that day, when I sat down in the air conditioning, the pain set in. The muscles in my back clenched up. I couldn't move my neck for days. I couldn't sleep for a week. I ate a bottle's worth of ibuprofen and wished that I had enough money to go see a doctor who would give me real painkillers, or wished that I still knew drug dealers who could sell me painkillers that I could afford. But that was just physical pain, and it's gone now. Now, that accident is a good memory for me. It was a beautiful moment in my life.

When I first saw the old man waiting for me on the side of the road, his face was excessively red and his breathing was short and shallow. My first thought was, Jesus, I hope I didn't shock this old guy into a heart attack. I can't say for sure what his first thoughts were, but his first responses towards me all had to do with my well-being. We were two strangers who met under awful circumstances, circumstances that left us both vulnerable. I could have sued him for the trauma associated with my injuries. I may have even won because I did have the right of way, and he should have seen me. He could have conceivably counter-sued me for damages to the hood of his car. He may have won because I was outside of the crosswalk when he hit me (though just barely outside), and besides, I'm sure he could've afforded a much better lawyer than I could've afforded. But rather than recoiling into self-preservation, we treated each other openly, honestly, and compassionately. That's a rare thing in our society. It is rare for concerns about other human beings to supersede concerns about money. And that's what real beauty is all about.

Face the Flying Sewage

So that was me, Bo Dunbar: the high school kid swinging a sixteen-pound sledgehammer against the lid of a septic tank. Not thinking about anything significant—not thinking about what I was doing at all, in fact—just whacking away at the lid of the septic tank, watching the concrete chip and fly away and the cracks spider towards the edges.

When I look back on that day and what I was doing, I have to ask myself: what the hell was I thinking? Why the hell was I even there in the first place?

I actually do remember what I was thinking. I was thinking about money. Running numbers through my head. Thinking, okay, I'm making $3.35 an hour (minimum wage at the time) and this job will take me eight hours, so that's roughly twenty-seven bucks, minus about twenty percent for Uncle Sam, drops me down to about $21.50. I'll pick that check up next Friday, dump ten bucks worth of gas into the truck, spend five bucks taking Michelle and me to a movie—if I can get up the nerve to ask her—and still have some money to get through next week.

So that's what I was thinking.

As for why I was there, well, my dad was a construction contractor. From the time I was thirteen until I went off to college, I spent most of my summer days and a lot of weekends and some after-school hours working odd construction jobs. Whenever I needed money or my dad had a job that he just couldn't talk anyone else into doing, I went to work. Usually, I hauled construction trash to the dump, scraped old shingles off of a roof, laid sod, ran a jackhammer or a compactor, that kind of thing. All very highly skilled, mind challenging work.

On this particular summer day, my dad couldn't talk anyone else into busting open a septic tank and filling it with crushed rocks. So that was me swinging the sledge against the lid of the tank. And as I hammered away, I asked myself why the old man couldn't talk anyone else into doing this job. It was then that it finally occurred to me that

pretty soon, I was going to break through the lid, and two or three hundred pounds of concrete were going to cannonball down into a tank full of raw sewage. All that raw sewage was going to come splashing up, and I'd have no chance to get out of the way in time.

Oh, fuck, I thought. Shit. Literally. Goddamn it. What did I get myself into?

I started swinging the sledge gingerly, barely tapping the concrete with dainty little dinks until I finally stopped swinging the sledge altogether. Fuck this, I decided. I'm going home.

I put the sledgehammer in my truck and started to drive away, resolved to forget about the septic tank and the rocks and the $21.50. To forget about Michelle and the movies and my job and the hot summer day and just go home. To spend my day in air conditioning, reading a book or something. But I hadn't even left the property before I realized that if I went home, my dad would be there. He would ask me if I had finished the job. I couldn't tell him no. I turned back around.

I got back to work thinking, fuck it. Fuck it all. Time to face the flying sewage.

I was determined to get this over with. I crashed the sixteen-pound sledge into the lid of the septic tank again and again. Banging away. It started to crack and give. I could hear chunks from the underside of the lid splashing down into the tank. I even made myself believe that the lid would come apart in small pieces and that the shit wouldn't splash too high. Then, it happened.

It's funny how time can seem to go by in slow motion. How you can watch things travel through the air and a million things run through your mind in a span of time that you know can only be a split second. You can watch the head of the sledge crash down solidly on a widening crack. Watch two giant chunks of concrete give way in the middle and fall. See the septic tank open itself up to you. Smell decades of crap. Realize it's time to run. Pull back the sledge. Turn and step and never take your eyes off the chunks of concrete belly-flopping into the shit and the shit flying up in big, viscous globs. Launch off your left foot and run just as those big globs unfurl like the head of a cobra, then strike, barely missing your right leg and barely splattering across your shoe and shorts.

Fucking-A.

A little shit got on my shoe. A chunk stuck to the hair on my legs, but didn't actually touch my skin. A decent-sized gob stuck on my right hip. Luckily, though, I had an extra pair of baggies in my truck. I took

off the shit-covered shorts, tossed them into the septic tank, and put on the baggies. I rinsed off my leg and shoe with water from my water jug, and I got back to work, thinking, was that all? That wasn't so bad. Not nearly as bad as I thought it would be. I don't know what I was so worried about.

But that wasn't all.

I busted up cinder blocks and tossed the small chunks into the tank until it was filled past the sewage line. I shoveled dirt in until I couldn't see any shit at all, then broke up the rest of the lid and filled the tank with more dirt and concrete until it was all level ground. When I was done, I drove my truck over the spot where the tank had been. I did this a couple of times, just to make sure that the new ground wouldn't cave in on itself. It didn't.

Over the course of the next month, a mason poured a concrete pad, and a carpenter set a load-bearing post over the spot where the septic tank had been. The pad and post and old septic tank eventually held up the corner of a new front porch and a small section of roof. But I didn't care about any of that. I just cared about finishing the job right the first time, getting paid, and going home.

I left the job site that day, pulled out onto North Tropical Trail, felt the wind through my t-shirt cooling my sunburned shoulders, and I let out a little laugh. Barely missed that shit, I thought. All that worrying about concrete and raw sewage, and it didn't amount to anything except a little extra dough. I ran the figures through my head again and thought about where to spend that money and decided to stop at a convenience store and grab a drink.

Michelle was walking out of the convenience store just as I pulled up to it. How convenient indeed, I thought. I had just earned enough money to take her to a movie and here she was, waiting for me to ask her out. I parked and stepped out of the truck feeling a little more confident than usual. Because I'd been out in the sun all day, I knew my tan was a little darker than usual. Because I'd swung a heavy sledgehammer for eight hours, I knew I looked a little stronger than usual. And, though I was a bit sweaty and probably didn't smell too great, I felt like it was a man's sweat and a man's smell, and I was a man who had just done a man's day's work. I felt like, for the first time in my life, I wasn't going to be all jittery when I asked a girl out. I strolled over to Michelle and said, "Hey. What's up?"

"Hey, Bo. Not too much," she said and looked up at me. "What're

you up to?"

"Just got off work," I said. I looked Michelle in the eyes. They were such a light blue that they were almost gray in the sunlight. Michelle didn't look back into my eyes, though. She glanced around the parking lot behind me, like she was trying to find someone.

"You're doing carpentry, right?" she asked.

"Not today. Today I worked demolition. I'll work for the carpentry crew tomorrow," I said. Michelle kept checking out the parking lot. I turned to look behind me, but nothing was out of the ordinary.

Michelle finally looked up at me. "Do you smell something funny?" she asked, taking in a deep breath and glancing around again. "It smells like someone shit their pants."

I didn't catch on quickly enough. It can't be me, I thought. I didn't shit my pants. "I don't smell anything," I said.

Michelle crinkled her nose. "I definitely smell something."

I shrugged my shoulders and thought to myself, it's probably best to change the subject. Talking about something stinking wasn't a good way to segue into asking a girl for a date. I tried to think of something else to say. Nothing came to mind, and Michelle was distracting me, sniffing around like that. I took off my baseball hat. It was kind of an unconscious nervous habit. My hair fell onto my forehead and over my ears. I knew I probably looked like hell, so I tucked my bangs into my hat again. As I was doing this, I let my hand graze across the hair on the back of my head, where I felt a chunk of sun-hardened mud. Strange, I thought. It wasn't muddy where I worked today. Then, very slowly, I realized: that's not mud.

Suddenly, all of my confidence crumbled. I wanted to find a dark hole somewhere—a dark, clean hole—and crawl into it. Don't do it, I told myself. Don't freak out now. Just act like it's really mud. Believe it's really mud. Work through this one, too.

"I can't really stick around and chat, Michelle," I said. "Sorry about that. I'm, uh, in kind of a hurry." I picked the chunk out of my hair and tossed it onto the sidewalk, trying like hell to be nonchalant. "I'll call you later, though. Maybe we'll go to a movie or something this weekend."

"I'd like that," Michelle said. She walked towards her car. I headed for the convenience store bathroom.

I was pretty pissed off at my dad when I got home. I wouldn't talk to him at all. I didn't talk much to anyone for the rest of that week. I

just went to work and toted lumber or banged nails or picked up trash, came home, sulked, and went to bed. The whole time, I was grumbling inside. Thinking to myself: this is me. This is who I am. In the whole grand scheme of things, I'm the guy who gets the shit job. This is my station in life.

I didn't stop grumbling until my date that Friday night.

I showed up at Michelle's house with my hair still wet from the shower. (I'd wanted to make sure I was clean. The shit was still on my mind.) Michelle opened the door and said, "Hey, Swoboda." I melted a little because she called me by my full first name—Swoboda—and because I could tell from the cracks in her voice that she was as nervous as I was.

She wore a dress that I'd never seen her wear before, but the cotton looked soft and worn. "Is that a new dress?" I asked.

"New to me," Michelle said. "You like it?"

"I like it a lot," I said, but I didn't tell her that I thought it was especially cool because it was second hand. Something about the notion that she wanted to impress me so she bought a new dress made me feel cool. Something about the fact that she had to buy that dress at a thrift store relaxed me. And, suddenly, the shit that had bothered me all week didn't bother me at all.

We went to a movie, but it wasn't very good. We ended up leaving halfway through, going to the dollar store, buying a bunch of candy, and going to one of the houses I'd been working on. We sat on lawn chairs on the back patio. The moon shone down through the bare trusses. Michelle talked and stuffed her mouth with candy, and I talked and stuffed my mouth with candy. When we got sick of snacking, we talked some more, and after a while, we started to make out. I didn't think about shit the whole time. I didn't think about shit until Michelle and I were in the middle of making out and she ran her hand through the hair on the back of my head, right where the chunk of crap had been. For a second, I felt ill. Then I told myself, fuck it. Fuck it all. That sewage is buried for tonight.

My Broke and Homeless Ass

My Broke and Homeless Ass

On my way to the Casablanca to see Helen, to have her feed me swill beer and deal out my weekly dose of rejection, I ran into Danny. It was purely by chance. He was on his way to a topless bar to hide from his girlfriend. "I may have to ship her ass back, Bart," Danny told me. "She's spinning her head around in circles and shoving crosses up her cunt again."

"You know you're going to the first place she's gonna look," I said. But he knew. That's probably why he was going there. "Let's get a beer somewhere else."

"I ain't going there," Danny said. He knew me too well. He heard the slur of my words; he saw the red in my eyes. He knew where I was headed.

"Then we're at an impasse."

We looked at each other. Traffic rolled down A1A; no breeze blew off the beach. Even as evening approached, it wasn't getting any cooler. It wasn't going to. I looked up at the sign for Miguel's. Until I did, I hadn't realized how hungry I was. But I hadn't eaten since breakfast, and it wasn't like I had food at home. Danny thought the same thing, so we went in.

Miguel's was a favorite haunt, good food but also the kind of place you could come into straight from the beach, barefoot and sandy, and it was no problem. One of the waitresses was a Cuban girl, probably twenty, with hair so black it sometimes looked blue, and a low, sultry voice. We stood by the door until we could see which section was hers, then took one of her booths. When she asked, I ordered a beer. "We still don't serve beer here," she said. I knew that. I just ordered one so she'd remember that I was that gringo who always comes in drunk and orders a beer. I figured she could look at me in one of two ways. Either I was an idiot with no long term memory, or I was a hopeless romantic, knowing that the world doesn't conform to my needs but never giving in, always grasping on to the shred of hope for a better life, of a world where I can get a beer with my pork and rice.

"Coke, then," I said. Danny ordered the same. She left two menus

and headed back for the kitchen.

Neither of us picked up the menus. "So Danny," I said. "The drugs ain't doing Sophie any good?"

He shook his head. "They were. She was fine for the first couple of months. She's fine when she don't drink. But the last few nights, dude..." He stared off. He didn't have to tell me. It was always the same story. Only the places changed. She'd spend a couple of months institutionalized or in rehab, then she'd come out the vision of an angel, soft-spoken, polite, friendly, and Danny'd fall for her all over again. It usually lasted about six weeks, then Miss Hyde would come back, and Danny would be right back where he started from. I think he liked it that way. At least she wasn't boring, and he could cheat on her six months out of the year. He just had to keep her from beating his ass too badly.

The waitress came back with our drinks and said, "You guys gonna try something different this time?"

"I ain't," Danny said.

"Me neither."

"Pork and rice?" she asked. We both nodded, and there it was. She was the same kind of hopeless romantic, grasping on to the belief that someday we'd try the beef or chicken or one of the sandwiches; one day we'd go for potatoes or mixed vegetables. Yeah, I started to think, she and I were made for each other.

"She told me she'd quit it all and straighten up if I could tell her what the meaning of life is," Danny said.

"The waitress did?"

"No, dumbass. Sophie."

"What did you tell her?"

"I told her I'd ask you and get back to her."

Ask me? I thought. Why would you ask me? If there were ever a low point in my life, I was there. Six months earlier, my girlfriend had heinously dumped me, and, during the course of that week, my DUI fines and other debts had built up to the point where I had to sell my car to pay them. Then my parents kicked me out of their house because they said it was the only way I was going to get my life together. I'd been living on couches from that point on. Then I got fired from my job of selling frozen meats. Then I got another job and got fired from that. Then it happened again. Then again until I finally ended up working for the county, watching kids for the summertime. And I was spending all my time and money at the lowest of dives on the beach, hitting on

Glue and Ink Rebellion

Helen the bartender and having no luck at all. If anything, I was the one person who didn't know shit about anything. To ask me the meaning of life was like asking Michael Jordan for tips on your batting stance. "How the fuck would I know?" I said.

"You wouldn't," Danny said. "But Sophie likes you. She told me that you're the smartest guy she knows."

"If all the people you know in the world are idiots, and one person is just a little less of an idiot than everyone else, he'd look like a genius, wouldn't he?"

"What are you saying?" Danny asked. "That we're all idiots?"

"No. Just me and Sophie."

This calmed Danny. He watched the waitress walk by and stared at her ass all the way to the kitchen. "So?" he said.

"So what?"

"So what's the meaning of life, Bart?"

"I don't know. Carbon?"

"Carbon?" Danny said. "That's the dumbest fucking answer I've ever heard."

I shrugged my shoulders. I wasn't going to apologize for my lack of intelligence. The waitress came back to refill our sodas and tell us that the food would be ready in a minute. And there was something about the way she leaned over the table, breasts close to my nose and her eyes looking into mine so that I couldn't ogle. It got me thinking that maybe she was thinking of something. So I asked her the question: "What's the meaning of life?"

She stood up straight and smiled. "Everyone knows that." Then, she walked back to the kitchen.

"Well, there you have it," I said.

"Carbon," Danny said. "I can't tell Sophie anything that stupid."

"Well, it's a stupid fucking question," I said. "If you want to know the meaning of anything, look it up in the dictionary."

"You know that's not the answer she's looking for."

Of course I knew. All I could say was, "She ain't my girl."

The waitress came back with our food. We ate in silence. While we did, the waitress kept circling around our table. Every time she'd walk by, she'd look me in the eyes and smile. Every time we'd take a sip of our sodas, she'd come by with a pitcher and refill them. Four times she asked if the food was all right. I started feeling good about my chances.

I kept thinking about Danny's question, too, while I ate. Finally, I

started sobering up a bit and returning to the belligerent state that I'd fallen into when I was at the beach earlier that day. "It wasn't a stupid answer, if you think about it," I said. "Because if you can bring everything down to atoms, all the world is is a random collection of atoms, built on each other to form things, and the only collection of atoms that all life has in common is carbon. And if all we are is a random collection, then that's what we mean. And it seems to make sense that the only thing life is is random. Random events and chaos."

Danny shook his head. I knew he wasn't buying it. I wasn't really buying it, either, but I wanted to be ready to defend myself if he called me stupid again. "I can't tell Sophie that," he said. "That would just make matters worse. Her life is too random and chaotic as it is."

"Well, hey man," I said. "So's mine, and that's the belief that keeps it going. I'm doing fine."

"I wouldn't call how you're doing 'fine.'"

I sopped up the last bit of spices and grease off my plate with a chunk of bread. "I would." I put the bread in my mouth, but kept talking. "Outside of the lamentable fact that I ain't been laid in six months, my life's pretty damn good."

"Oh, yeah," Danny said. "How much money do you have?"

I reached into my pocket and pulled out my wad. A fifty, six twenties, a ten, and a couple of ones. "I still have almost two hundred bucks left."

"How much do you have to your name?"

I smiled. "I still have almost two hundred bucks left."

"How much of that do you think you'll have Sunday night?"

I shook my head. "Hey, anything could happen. This could be the week I land on my feet."

"More likely it'll be the week that I have to let you sleep on my couch."

"But, see, you don't know because it's all random events and chaos."

Danny stood up. "I ain't buying it." He turned and walked to the bathroom.

The waitress came back at this time. She sat in the booth across from me, crossed her arms, and leaned on the table. A gold cross dangled in her cleavage. God liked me. "You were born here in Cocoa Beach, weren't you?" she said.

I nodded.

"I knew it. You have the look."

"What look is that?"

"You know." She stuck out her chest and threw back her shoulders. "That cocky look. Like you just out-surfed someone and no one saw you so you got to strut around to make news of it."

"I don't surf."

"That's good. That's points for you." She looked over her shoulder. Danny was coming back from the bathroom. "Tell me," she said, standing. "Would you like to be my escort to a picnic tomorrow?"

"I'd love to." I tried to hold back my surprise, to be as cool as I could, but after a six month dry spell, this was too perfect.

"Pick me up tomorrow morning. Ten o'clock. I'll draw you a map before you go." She smiled and seemed to look through my eyes. I tried to smile, too, but did a bad job of it. Then she walked away.

She gave me a map when I paid the bill and, from there, we went back to Danny's place, a few blocks away, where a party was in progress, and I went on to drink myself back into a stupor. Then, we went to a raw bar across from Miguel's. The only thing standing out in my mind about the night from that point on was the Magic/Pacers game and a guy sitting next to me who remembered me from my days at Tennessee, when I was a Division I athlete and kind of a great white hope, six foot tall and slow, but first team all-SEC two years running and averaging just under seventeen points a game. He bought me a shot every time the Magic took the lead back, which happened too often. Everything after that was a blur. But I did blow a good bit of my paycheck, as prophesied.

I woke up the next morning on Danny's living room floor. It was about seven o'clock. The duffel bag I was living out of was my pillow. I grabbed a towel and some clean enough clothes and showered. No one else in the place was awake. The longer I stayed up, the worse I felt. The whiskey the night before had been a bad idea, but nothing compared to the tequila. Visions of vomiting came to me followed by visions of schnapps. I tried to convince myself that much of it was a dream, but I knew better. At least it wasn't me who vomited. Still, the painkillers given to me by that dude who bought me the shots marked the beginning of my descent and the end of my memory. And vomit could've easily fit itself into my morning. I searched out Danny's passed out body. Evidently, Sophie had found him because they were sleeping together in his bed. I shook him until he woke up, then talked him into getting up and drinking with me until I was supposed to go to the party with the Cuban goddess.

We found a bottle of Rumplemintz in the freezer and a couple of bottles of Busch in the refrigerator. Between the two, we had no problem making it until ten. Other passed out bodies scattered across the living room floor came to life and joined us at the table, but we wouldn't share our hooch. We all sat around, filling in aspects of the night before that others had forgotten. And I spent most of the time trying to bum a car off someone. No one but Danny believed that I had a date, even though I had showered. Danny wouldn't loan me his car, either. I guess he wanted a way to escape Sophie if she started to wig. My buddy Jeff needed his car because he was living out of it. Rick surfaced out of one of the bedrooms, but when I asked him if I could borrow his car, he told me to fuck off. He said that he'd given me a job and that was enough. He also pointed out to everyone else that I didn't have a driver's license. After that, no one was going to loan me their car. I finally decided to steal Sophie's keys. She was crazy, but she wouldn't call the cops. No one at the kitchen table tried to stop me. So, wearing the best duds my duffel bag held and carrying a healthy but inconspicuous buzz, I set out in my new Geo Storm to pick up my new love.

I followed the map into Snug Harbor, a family neighborhood up around Fourteenth Street. She lived at the end of a cul-de-sac in a two story house that was a little upper class for me. I knocked on the door. Her father answered, and that was my first problem. I'd forgotten her name, so I couldn't ask for her. I tried to make a joke of it. "I've come for your daughter," I said.

A look came across his face like he'd just finished having this nightmare, then he invited me in. Inside was a showplace, black leather couches and chairs, space age furniture, and a huge parrot in an elaborate cage that kept saying, in the father's voice, "I kill you. I kill you." The father sat me down and sat himself down facing me and said, "My son, have you accepted Jesus Christ as your personal savior?"

"Yes. Yes, indeed," I nodded. What the fuck else was I going to say?

He looked at me for a long time to see if I'd crack, but I held up, met his stare. Then, he smiled and slapped me on the back. "You can have my daughter then," he said and laughed a gruff and sinister laugh that he should've had patented. "Maria," he called out. "You must not keep the gentleman waiting."

That's right, I thought. Give the gentleman some respect, Maria. He and Jesus are tight.

Maria came out looking fucking hot in a black halter top and white shorts. I could see it was a situation that called for old world etiquette. I stood when she entered the room. I offered her my arm. I opened all doors for her. I figured I could keep it up until we hit the party, then gradually drink myself out of a buzz. Or get her to drink herself into one.

As we drove along, I did all the talking. I was very cautious, not rambling at all but measuring everything I said, trying to see what was cool and what was taboo, like did she smoke pot and how much did she drink and was it just a picnic or a party and just what were her views on sex on the first date. But it was all very subtle. If she were game, she'd figure it out. If she weren't, then I'd only seem random.

She answered everything monosyllabically. The only full sentences she put together were the ones telling me where to turn. She sent me north into Cape Canaveral, then west across the bridge into Merritt Island, north again up State Road 3, and when she leaned forward and said, "Take your next right," I knew I was going to the fucking Calvary Chapel. Dead center into the religious right.

I parked and walked around and opened the door for her, all the while trying to think of the quickest way out of there. I knew these bastards. They'd tried to save me before. I had a feeling that Maria's intentions were less honorable than mine. I was just trying to fuck her, not fuck with her eternal soul and worldly cash.

I offered my hand as she stepped out of the car, but she didn't take it. She walked a step ahead of me. I followed like a sheep. Or I guess like the flock. Anyway, she brought me into the white shining heart of it. She introduced me to a tall man, balding but with that long bang that he wrapped around his head so that it looked like it should look like he had a full head of hair. "Bart," Maria said to me, "this is my minister, Reverend Grisham."

Reverend Grisham grabbed my hand tightly, like someone was going to cuff me before he let go, and asked, "Are you thinking of joining our congregation, Bartholomew?"

Bartholomew? Who was this fucking clown and why did he think he could make my perfectly good name biblical? I wanted to tell him to fuck off, but instead I said, "Oh, yeah, I talk to God every day. It just seems right that I should do it in a church."

"I look forward to seeing you here tomorrow morning," he said.

I thought about leaning forward and whispering in his ear, asking if I could get at some of that blood of Christ that these places are so

famous for, but he turned away. He had other souls to save.

Maria led me through more of the congregation, introduced me to the deacons, showed me all of the Chapel, told me of all the wonderful things the church had opened up for her. As she preached the word, my buzz faded and my hangover bulldozed in. I started to sweat so badly that I could smell the booze seeping out of my skin. More than once my vision shrunk down to the size of a pinhole and I thought I might pass out on the spot. The heat and humidity didn't help at all. I was dying in God's steam room. Then she dragged me out to the back lawn, where the food was set up, and where she introduced me to her boyfriend. Lucky for me, though, I knew him. Frank Willis, the one-time biggest dealer on the Island. He used to sell the cleanest acid in the area. He mixed his own speed. He had two acres in the swamps where he managed to raise the fattest Indonesian plants. He saw me and shook my hand suspiciously. "Maria," he said. "Would you mind getting us a couple of cups of punch?"

Maria smiled the smile that reminded me why I was sucker enough to get into this mess in the first place, then strolled over to the refreshment table. I looked around to see if anyone was within earshot. When I felt it was safe, I said, "Goddamn, Frank, am I glad to see you. I'm fucking dying here. Say, sorry about moving in on your woman. I didn't know. I'll back off. Don't worry. But look, bro, I'm so fucking hung over. Do you have anything to help me out? Please, man, help me."

Frank looked at me with no sympathy and said, "Don't use the Lord's name in vain."

"Goddamn," I said. "What's gotten into you?"

"The Lord." And then, for the second time in a day, a man asked me, "Have you accepted Jesus Christ as your personal savior?"

"Fuck you, man," I said. "I need drugs."

"I'm out of that, Bart."

"Bull fucking shit," I said. "What about that sack you sold me a week and a half ago?"

"That was before Maria showed me the way. Maybe you should open your eyes and look around you. Your soul's at stake."

"Man, Frank, I can hardly stand hanging out with these people now. I sure as fuck don't want to spend eternity with them."

"You don't know how blind you are."

I didn't feel like arguing. It wouldn't do me any good. "Maybe you're right," I said. I looked over at Maria, looking virginal with her

little Christian sisters, pulling her whore for Jesus routine. And how I would've liked to fuck them all in their pristine summer outfits, but I always thought church a suspicious place to hound chicks. I reached into my pocket. I still had almost one fifty of my cashed paycheck. I separated the fifty from the wad and said, "Check it out, Frank. Half a bill for whatever fair deal we can make."

Frank looked at the fifty. He seemed to think for a minute. "Meet me at my truck," he said in a whisper.

He had ten hits of acid, a half full bottle of Vicodin, and a little more than an eighth of weed in the glove compartment. He gave me all of it for the fifty. "I know it's worth a lot more, but I'm out of this business," he said. "And I hope to see you rot in Hell."

I took it all indeed, and for the first time that day I thanked God, whoever She may be. "I hope to hell Maria's worth it," I said, then I hopped in the Storm to meet up again with my people.

I stopped at the Gas and Sip across from the Calvary Chapel, where I picked up a Gatorade and a pack of wraps. I rolled a pinner in the parking lot. It would be another thirty minutes of driving before I reached Danny's. My head just wasn't feeling any better. I lit the joint as I pulled out onto State Road 3. I washed down two pills with the Gatorade. I turned up the radio. By the time I reached the Cocoa Beach city limits, the world blended into a nice fuzz. So Maria turned out to be the evangelistic version of a Krishna in an airport. It was still Saturday morning. Danny was still having a party that day. So was the city of Cocoa Beach: the annual start of summer block party. With any luck, Helen the bartender would be there and be there drunk and I could turn the tables on her. It was her who I'd wanted all along. Not that Cuban priestess.

The sky was a light blue and the beach was something out of a poster in a travel agency. I'd made a score that would make my broke and homeless ass a hero. It may not have been the week when I was going to finally land on my feet, but I felt like things were definitely going my way.

When I parked across the street from Danny's, one crowd was sitting around an already tapped keg in his front yard, and another group was shooting hoops in his driveway. I stepped out of the car thinking, yes, indeed, this is my day. That was when Sophie tried to tackle me. She took a running leap and landed on my back, wrapped her arms around my neck and tried to bite my ear off. I managed to shake her without hitting her. Then, she started swinging at me, closed fisted,

really trying to fuck me up. Mostly, though, she just hit my arms and stomach until Danny pulled her off.

"You son of a bitch," she screamed. "You stole my car. You son of a bitch."

"No, no," I said. "You told me I could take it this morning. Remember when I woke you up and asked you? Told you I had a date?"

She looked up at Danny, who was still holding her back. Danny nodded. "He's telling you the truth." Sophie stared at Danny to see if he was lying. Even though he was, his face didn't betray him. When she finally believed him, she became suddenly calm. So suddenly it was scary. Her face became a blank slate. She smiled, turned on her heel, walked back to the keg, and poured herself another beer.

I let that whole scene slide. I joined the others at the keg, where I told the story of my big drug score and everyone was pretty amazed. Scoring drugs at wholesale prices at the Calvary Chapel isn't the easiest thing in the world to pull off. Still, they all let me know that part of my problem could be that I buy drugs even at church. No one squawked, though, when I twisted up two more joints and passed them around the circle. I twisted the rest of the weed into four joints and fit them into the long bottle that the pills were in. I figured I'd go through that over the course of the weekend. The acid I'd keep until Sunday night, then unload it so that I'd have enough money to make it through the week.

Sitting around the keg, shirts off, sweating, telling tales in the front lawn summertime was perfect for a while. Time whittled away that way. After a couple of hours, the beer and weed and sun started to make me a little groggy and my plans that night were too big to be sleepy for, so I joined the game of hoops. A game to eleven and I hit eleven straight outside shots. Make it, take it. It really wasn't fair. The other guys didn't even get to touch the ball, so they banned me from the game. They left me with no choice but to take a nap.

At around seven, Danny woke me up. He told me that Sophie was dead set on going to the psychic before she went to the block party. Since I owed him for saving my ass in the stolen car incident, I had to go with her.

I crawled out of bed, slapped my face a couple of times, and said, "As long as I can bring beer."

The psychic was much cooler than I expected her to be. She was in her late twenties with curly blonde hair, a wraparound floral skirt, a plaid flannel shirt, and platform shoes that still didn't raise her to three

eleven. She held out her tiny hand, and I shook it. "Do you mind if I drink beer in the waiting room while you two take care of business?" I asked her.

"Not at all, sweetie," she said. I headed across A1A to the 7-11 to grab a quart.

Sophie was in the back room with the tiny prognosticator for quite a while. I finished the quart and downed two more pills. The nap had killed my buzz, but it came right back, just like a faithful dog: feed it, and it'll make you happy. There wasn't much in the waiting room to look at, some New Age magazines, tie-dyed drapes, a framed picture of the psychic standing in front of the shop with Burt Reynolds. I walked around in circles, impatient. The sun was down, the night had cooled to about ninety-five degrees, but the ocean breezes brought it down to probably ninety. The block party had already begun, and I was itching to get there, to listen to the cheesy cover band set up in front of the Cocoa Beach PD, to buy a Polish sausage and beer from the Jaycees, to throw down my buck and try to dunk the mayor. And it would be the perfect night for romance amidst the insanity of the summertime heat, under the half moon, two blocks off the Atlantic. It was definitely my kind of night. The kind of night that kept me stuck to this coastline for so many years, and I was wasting it pacing back and forth, waiting for Sophie to find out what her future held. Shit, I could've told Sophie what was in the cards for her. She'd wig out at some point in the next three days, disappear for a week and a half or so, lost in the haze of a binge, then show up at her father's place greasy-haired and smelling like shit, eyes bleeding, and five to ten pounds lighter. She'd probably sell her car during that binge for three or four hundred dollars worth of crank. I'd have to go with Danny to work over the guy who bought the car and bring it back. Her father would send her to a shrink to decide which institution to stick her in, and that would be that. Right back into the cycle.

But that wasn't what the psychic was telling her. I was sure of that. I was sure that she was telling Sophie that she'd find love that night or riches or some shit like that. That's what I'd say if I was that psychic. That's where the money is. That's why Sophie went to her instead of me.

Sophie finally came out with the psychic and told her that I'd pay. I'd figured as much. Sophie's dad was loaded, and he'd give her anything she wanted but cash. I asked the psychic how much I owed her.

"Twenty dollars," she said.

I handed her the twenty and said, "Did she ask you the meaning of life?"

"No," the psychic said. "Do you want to know what it is?"

"Do you know?"

The psychic grabbed my hand and turned it to look at my palm. She ran her tiny finger between my forefinger and thumb, across the palm. "Interesting," she said.

"What's that?" I asked.

"You have no life line," she said. She looked up into my eyes. "I can't believe you're still alive."

"No one can," I said.

"This is serious." She tilted my hand so that more light shone on it. Then she shook her head. "I've never seen this before."

"I probably just rubbed it smooth beating off," I said. I laughed, but Sophie and the psychic didn't think it was funny.

"I think you're going to die tonight," the psychic said.

"Then I better get some drinking in while I still can. Come on, Sophie."

Sophie didn't budge. She stared at the psychic. I grabbed her arm and dragged her out. Sophie followed, but like she was in a trance. I rushed her along, anxious to unload her on Danny.

We walked along A1A without talking. I could see the lights of the block party up ahead. I could almost taste the beer, smell the women. Sophie snapped out of it in front of the topless bar. She reached down, grabbed my hand, and stopped walking. "Oh, Bart," she said. "You're gonna die."

I pulled my hand from her grip. "Not necessarily. There's five billion people wandering around this earth who were all born and haven't died. This could be our time. We could be the first generation of immortals. All of us stuck here together forever." I smiled. "That's a scarier thought than death, ain't it?"

"Be serious, Bart. You don't have much time left."

"Don't buy that psychic shit. What else did that broad tell you?"

"That I'd go on a bender in the next week and end up selling my car and land in rehab before the next full moon."

I looked up to the sky, the moon halfway to full. Like I said, that psychic was much cooler than I'd expected. The thought made me laugh.

"Don't laugh. You're gonna die."

Glue and Ink Rebellion

"Get off it, Sophie," I said and started to say more, but then I felt her hand on my dick. She stood on her tiptoes and kissed my earlobe. I jumped back. She grabbed my hand again.

"Have sex with me, Bart," she said. "Right now."

It startled me so much that I couldn't respond. This was Danny's girl. I couldn't do it to him. He gave me a place to crash for free when my parents wouldn't. He was my oldest and closest friend. But shit was fucked up between him and Sophie. They cheated on each other so much that there couldn't be a betrayal because there was no loyalty. And something about the way she stared up at me with those big brown doe eyes and stood close to me with that tall, slender frame. Even if she was slender because of all the speed and even if the beauty of her eyes was because of the insanity behind them, she was so pretty in her cotton dress, and it was summer and hot, and I was horny, and there was no law of the universe to guarantee that just because six months had passed without me getting laid, six more wouldn't. But because of where we were, we'd have to go back to Danny's to fuck, and Danny wouldn't be there, but Sophie and I would fuck in his bed, and he'd have to sleep in the dried spot where I came, and if he went down on her that night, damn. So much raced through my head so quickly that I thought I'd pull a neuron. Fuck, ethical choices should be left up to ethical people and leave me out of the loop altogether. I pushed Sophie away.

"You have to leave me something, Bart."

"I'm not gonna die."

Sophie lunged at me and pushed me onto A1A. I jumped back on the sidewalk just in time to feel only the wind of a passing car. "Fine. Fuck you. I hope you do die. I'm going in to look for Danny." She disappeared behind the door of the topless bar.

"Have a good time," I said after she was gone. She wasn't really looking for him. She was hurt and embarrassed and, if I knew her at all, she would think that I'd rejected her not because of loyalty to Danny but because she was somehow deficient. She'd go in and surround herself with women and give up on men for that night.

But, hey, that was cool. Alone was just how I wanted to be walking into the party. No baggage, nothing holding me down. No one to freak out on me. That incident could slide, too. Just elements colliding and dispersing: nature. Thoughts that beer could soak up.

With every step, my enthusiasm grew. I checked out the cars on the street, recognizing some: my old basketball coach's, my ex-girlfriend's little sister's, people like that. Everyone showed up for this

bash. There'd be chicks I'd known since high school, people I hadn't seen for years. My parents, probably. I was also sure that the lovely Helen would be out from behind the bar and maybe looking for love. It was the event of the season, and I was primed perfectly, ready to go. I turned west on Minuteman, towards the band, and headed straight for the beer concession. There was no line and my high school chemistry teacher was behind the counter. "Hey, Bart. Long time, no see," he said.

"Too long, Mr. Winters," I said. "Thought about coming in to see you a few times." Which was true, actually. Mr. Winters was a bright guy, deeply schooled in the mysteries too involved for the untrained eye. Every time I blacked out from booze, I thought about going in to see him. I figured it was a chemical reaction. If anyone knew how to avoid it, Mr. Winters would.

"What about?" Mr. Winters asked me.

"The meaning of life."

"That's easy," he said. "Carbon. What are you drinking?"

I grinned. "The biggest beer you got."

Mr. Winters poured me a thirty-two ounce draft. I paid, threw a buck in for the Jaycees, and said good-bye to him. Minuteman was crawling with people, so many that I couldn't pick anyone out in the crowd. I worked my way towards the band. If my crew wasn't hanging out around the beer stand, they'd be in front of the band doing some sort of silly dances. On the way I ran into a few people I knew. Not really friends, but people who I liked to see out on the town and enjoyed talking to if the conversation lasted five minutes or less. None of them knew the meaning of life. One had heard of my acid score and was looking to buy a few hits. I sold him three for fifteen bucks.

As I made my way through the crowd, I kept my eyes open for Helen. If there'd ever be a night for us, this would be it. She'd had the day and night off. When I was in the Casablanca a few nights earlier, she'd told me that she would be hanging out at the block party this Saturday. She'd also probably started drinking early in the day at the beach, which would put her in the perfect state of mind. She wouldn't hook up with me when she was sober and my drunk and homeless ass sat across the bar from her, drooling over her legs, asking her for the thousandth time what it was like meeting Hulk Hogan on the set of *Thunder in Paradise*, the late night cheese show that she'd been on one time for exactly as long as it took to walk in front of the camera in a bikini. No, nights like that were just prep work for when she hit the streets drunk and alone and looking for a friendly face, like I thought

she was probably doing at that exact moment.

As I neared the band, I saw what looked to be the top of her head. It could have been anyone, but as I got closer, I knew it was her. She was dancing with some guy who I couldn't see. Doing the lambada to a Georgia Satellites cover. I figured I'd try to cut in, anyway. It all went back to carbon. Just because two elements were combined at one point didn't mean that they'd stay that way. Nature constantly rearranges itself. It could rearrange so that it was me and Helen bonding.

I weaved through the dance area until I was ten feet from her. That was when she kissed the guy she was dancing with. That was when I saw it was Danny. That motherfucker. He knew I was nuts about Helen. He could've had some loyalty to me. I held back for him. Sure Sophie was crazy, but she was damn pretty and there was little I'd've enjoyed more that night than fucking her. But I was loyal to my friend. I crossed no line. I figured there'd be a perfectly good woman wandering around the block party. I hoped it would be Helen. I didn't figure this could happen. Fucking chaos. I turned and worked my way back out of the crowd.

All of it was getting to be too much for me. Shit builds and builds and I think it doesn't bother me, and then a point comes when I realize that I've been pissed off all along. Fuck the party. I was going back to Danny's vacant home to smoke pot and be alone. To let tomorrow come and let there still be money in my pocket and let things start to work themselves out.

Just before I got to the corner of Woodland and Minuteman, I saw a little girl standing in front of a booth, holding her mother's hand and pointing at a big stuffed bear. Her mother was trying to explain to her that she couldn't win the bear. It was impossible. The bear was just there for decoration. I stopped and checked the booth out.

It was one of those where you get three basketballs for a dollar, and the balls are about the same size around as the hoop. The hoop wasn't very far away, but the shot had to be right on. I looked at the girl and recognized her as one of my five-year-olds from camp. "Hey, Sarah," I said. "You having a good time?"

She smiled. "Yeah."

"I'm Sarah's camp counselor," I told her mom.

"The famous Mr. Bart," her mother said. "Glad to meet you."

"So you're trying to win the bear, huh?"

"It can't be won. You have to hit nine shots in a row."

I gave the guy behind the counter three bucks. I figured, what the

hell. There was only one fucking thing in the world I could do well and that was hit an outside shot. The guy handed me a basketball. I looked down to Sarah. "Now don't get your hopes up, kid," I said.

Sarah smiled and bit her lip.

I took the first shot and sunk it. The guy handed the ball back to me. "Eight to go," I said to her mother.

"It's your money," she said.

I nodded. I hit the second shot. And the third, the fourth, and so on. Nine straight. I didn't expect it, but then, I never expected my basketball experience to help me out in the real world and there it was, putting a smile on a little girl's face. The guy handed me the big bear. I put it under my arm and started to walk away. "Nice meeting you," I said to Sarah's mom. "See you later, Sarah."

Sarah looked at me, stunned. Her smile turned into a frown.

"What is it? You didn't want the bear, did you?"

Sarah shook her head.

"Good," I said. "I'll see you later."

I turned and took a step, then figured I'd tortured Sarah enough. I went back and gave her the bear. Both she and her mother thanked me. I just smiled and walked back to Danny's place.

His house was across from a warehouse about two blocks off Minuteman. No one was there. A basketball lay in the front yard. I picked it up and took a shot. Sunk that one, too. All luck against me that day, but I still managed to sink twenty-one shots in a row. I flashed back to my days of college hoops, but that didn't make me feel any better. I still had a few joints in my pocket. I lit one up. As I smoked, I thought back to the meaning of life I'd given Danny. I started to like it. The only solace I could find was in thinking that it was all random. That I could stand and take another shot and it didn't matter that I'd sank the last twenty-one shots. There was no force or universal law stopping me from sinking twenty-two. I walked halfway across the lawn, far beyond where a three point line would've been, bounced the ball a couple of times, then set it flying for the hoop.

Saturday Night at the Harbor

I went to Hawaii, which is strange for someone of my economic class, especially considering that I'm neither part of the armed forces nor a member of the merchant marines. Before going, Hawaii occupied a vague recollection in my mind of an un-air-conditioned Florida junior high school classroom where the underpaid teacher had snuck outside for a fifteen-minute smoke break in the middle of class. Two redneck kids fought in the back of the classroom. They woke me up and kept me up, so I sketched pictures of waves from *Surfer* magazine, pictures of guys like Gerry Lopez dropping in on the pipe while riding twin fin, Lightning Bolt boards.

I waded through those junior high days reading comics in Gifted English class, learning about Columbus's discovery of America and the fairly recent American victory in Vietnam, and trying not to get involved in the myriad daily fights, (mostly between the north Merritt Island trailer park kids and the central Merritt Island ghetto kids, but often spilling over into the more easily defined categories of black versus white, which made it more dangerous for me, seeing as how my skin was more or less one of those colors). I'd also learned to surf during my seventh grade year, and I dreamed of spending the upcoming summer surfing, all the while knowing that I'd spend that summer working construction. Concrete classroom walls seemed to sweat and the laminate desktops swelled and cracked in the heat, and I thought of Hawaii, where every girl looked like the models in an OP ad, where every surfer got a chance to slip into an overhead barrel. Where someday I'd land.

Eighteen years out of the seventh grade, I still dreamed of spending summers surfing, still knew that rent was a precarious sum to generate monthly without at least the occasional day of construction labor in the Florida sun (master's degree be damned). I was a part-time community college English teacher who could barely muster up the energy to pass out comic books to my students, who felt like I was giving the college too much for their money if I actually taught, and I

was well below the tax bracket of people who summer in the Pacific Islands (though I was seated comfortably in the tax bracket of people who qualify for food stamps). For more or less five years, my girlfriend Felizon put up with my daydreaming passivity until, finally, she put up enough money for both of us to go back to her hometown on the North Shore of Oahu.

Felizon and I spent ten days exploring her home state of Hawaii. I finally met her father, who filled me with endless stories of a life laboring for the sugar cane plantation, of a long lost civil engineering degree from a university in Manila, of cock fights in Mill Camp, of raising five children, and of his struggles saturated in forty years of heavy drinking. He also let me drive his hot rod Pontiac Grand Prix. Of course, he was my kind of guy. Felizon's parents fed us more Filipino food than we could possibly digest and more stories of Filipino culture than we could possibly learn. In times away from her childhood home in Paalaa Kai, Felizon took me around to the Hawaiian microcosms of the Philippines, Korea, Japan, and China. We took pictures of Japanese tourists taking pictures of King Kamehameha's statue. We wandered through botanical gardens and hiked up to a waterfall under the light of the full moon. We made friends with a six-year-old girl with leukemia. We snacked on all kinds of local foods: kal bi, manapua, poi, kalua pork, lomilomi salmon, and dinadaraan. We listened to a Tongan master drummer and watched Tahitian girls dance. We tried to avoid everything typically mainland American, especially the tourists, and got frustrated when we couldn't.

But this isn't a vacation story. I have a point.

We spent our first, second-to-last, and last night in Hawaii hanging out at the harbor in Hale'iwa with Felizon's brother, Felinor, and his friends. The first night, when Felinor told me that he and his friends hung out at the harbor and drank juice, I guessed that he was using "juice" as a euphemism. He wasn't. They really did hang out in the parking lot of Hale'iwa Boat Harbor, drinking Hawaiian Sun Orange Lilikoi or Strawberry Passion fruit juice, staring across the calm harbor waters and out to the ocean, "talking story."

The first night when I hung out at the harbor, I really enjoyed myself and couldn't fully understand why. The slow pace was just right for my travel-fatigued state of mind, the ocean had a soothing glassiness, and Felinor and his friends told pretty entertaining stories. At first they were somewhat guarded towards me (except Roy, but we'll get to him later). Maybe it was because I was a "haole" from the

mainland (and haoles from the mainland tend to be loud, obnoxious bastards), maybe it was because I had been dating one of their friends' kid sister for five years without giving her even an engagement ring (which I gathered is a bad thing in the eyes of a local boy). Probably it was a combination of both. Either way, I didn't let it bother me. I listened to their stories and joined in when it seemed necessary and didn't worry too much about winning them over. I left looking forward to meeting up with them again.

The second-to-last night, Felizon and Felinor wandered out of earshot to catch up on personal matters. Roy and I stayed in our seats and talked story. Roy is an easy guy to get along with. He's a native Hawaiian right down to the blood in his veins, and he has a humble confidence that makes him a friend right away. He told me a bit about his love life and a bit about the waves during the winter and a bit about growing up with Felinor, then he stopped in the middle of one sentence and said, "Do you hear that?" I listened. A four wheel drive truck turned out of the gravel harbor parking lot. Faint traces of reggae filtered over from Hale'iwa Joe's; the voices of kids partying at the other end of the harbor drifted over. Other than that, I heard nothing. Roy said, "I think there's waves."

I figured that he was pulling my leg, even though he didn't really seem like the leg pulling type. We kept talking. Ten minutes later, I heard it. There were waves. At midnight, I left the harbor with plans to meet Roy at six A.M. for a surf session.

Though I surf often, I'm not a surfer. I'm nothing like Jeff Spicoli or like the blonde, arrogant, in-crowd stereotype. I never have been. I rarely hot dog or ride a short board. I generally paddle out where the waves are a little smaller but at least they're less crowded. By the same token, although I'm not a surfer, surfing is very important to me. When I surf, I tend to forget my problems, but when I'm done surfing, I tend to understand my problems better. It's like hypnotherapy, I guess, only surfing is really fucking fun.

Surfing with Roy helped me in this way. The waves weren't the monsters that the North Shore is famous for. On my way to meet up with Roy that morning, I'd noticed that Waimea Bay was flat. The Pipeline was flat. Five guys fought for every ripple at Sunset Beach. But none of that mattered to me. Roy and I carried longboards across the street from his house and surfed clean, waist-high waves. We were the only ones out. Set waves rolled in every five or ten minutes. At first, we caught a bunch of waves. One other surfer paddled out. We made

another friend. A sea turtle fed off the reef that we surfed above. Rain clouds cast long morning shadows across the Waianae Mountain Range all the way down to Kaena Point. A couple of times, Roy caught me staring at the mountains and kidded me. Hell, I'm from Florida. All I get to see when I look back at the shore there is pink condominiums blocking out the sunset. Roy surfed in the classic longboard style of his father and grandfather. He coolly strolled back and forth on his ten-foot longboard, staying right atop the redwood stringer, calling out the ghosts of Duke Kahanamoku and his gang. I rode his twelve-foot longboard. It forced me to give up my lingering short board tendencies, to swing big bottom turns and run feet up to the nose. I adapted quickly.

When I left the water, I came to understand something about the harbor, about Hawaii, about haoles, about cultures lost and cultures gained.

My hometown is a shell of what it used to be. The Merritt Island culture of my childhood is gone, stripped away and replaced by Chili's, Office Depot, and Wal-Mart Supercenter. The last bit of wetlands on Merritt Island has recently been dredged up to make way for a BJ's Wholesale Outlet. The loss of this hometown is a major theme of my first novel.

My heritage is a shell of what it used to be. Although I know I'm of some kind of European descent, I don't know what part of Europe I descend from. Sean is an Irish name, but that doesn't make me Irish. For all I know, Carswell is just something some guy on Ellis Island made up. I know my family didn't come over on the Mayflower. I know I'm not indigenous to Florida. The constant sunburn and burgeoning skin cancer proves that. Locals in Hawaii make no distinctions between the heritage of white people. White people are all haoles. As far as I could tell, the only distinction is whether or not you're a fucking haole. A fucking haole is a white person who has benefited enough off of the American Wal-Mart Supercenter economy to be able to afford to vacation in Hawaii, but spends his whole time bitching about the lack of bagels and Starbucks (though there are plenty of both in Hawaii). I probably despise fucking haoles more than most. My years of building houses for fucking haoles (combined with my loss of culture and heritage) has led to a personal class grudge that's probably deeper than the one carried by most local Hawaiians.

The local boys at the harbor, though, made distinctions between every Asian and Pacific Island ethnicity. They knew the stereotypes for Koreans, Japanese, Filipino, Chinese, Hawaiian, Samoan, Tongan, and

so on. A lot of these distinctions are a throwback from the early sugar cane plantation days, when the fucking haole landowners separated laborers according to their ethnicity, then encouraged disputes between the different ethnicities. A lot of these distinctions come from the natural desire of people to hang on to their heritage, to maintain the good parts of their traditional culture and blend that with modern life on Hawaii. This is most apparent in the local pidgin dialect. All the guys out at the harbor spoke pidgin. Felizon's parents and extended family all spoke heavy pidgin. Felizon spoke it again after one night at the harbor.

When I first heard the Hawaiian-style pidgin, it sounded simple to me. When Felizon took time to point out the words I didn't know, and I realized that pidgin borrowed from Chinese, Japanese, Hawaiian, and all the other cultures that made up the plantation labor force, I respected it. Rather than sticking to the forced language of their boss (or their conqueror, depending on how radical you want to get here), the local working class made their own common language. It may seem like a tiny victory, but its cultural significance is as important as any other successful labor uprising. Take, for example, the phrase "talking story." When the guys hang out at the harbor, they talk story. When the same kind of guys hang out on the mainland and do the same thing, they bullshit. Bullshitting, shooting the shit, or whatever, suggests that your time spent talking about the important fragments of your life amounts to the same value as the feces of a farm animal. It's a term I never really thought about before, and though it doesn't have great significance, it does subtly demean the act of sharing experiences. To talk story (though it may be syntactically awkward) suggests that your idle hours of conversation are actually more than that. Your fragments of life are important, and the stories you tell represent the traditions of your heritage, and the good parts of these traditions adapt to the modern world.

So my last night in Hawaii, we all went back to the harbor. Felinor grilled mullet stuffed with tomato, ginger, and garlic. We ate that with steamed rice and local-style macaroni-and-potato salad. Roy and I talked a lot about our session. We didn't brag. We knew the waist-high waves were too small for most North Shore surfers. I knew I was no Gerry Lopez, would never be and couldn't even surf the same breaks on the same day as him, but I didn't care. Seventh grade *Surfer* magazine fantasies didn't mean much to me anymore. I'd rather surf with Roy

any day.

A soft, misty rain started to fall. It was nothing to pack up and go home about. Just enough to get us wet and make us pull our chairs under a tree. We drank juice and talked story. I looked across the glassy waters of the harbor half a world away from where I was born, and I felt at home. Then, I looked over at Felizon, a local girl once again in her slippas and Matsumoto's Shave Ice t-shirt. I listened to her talk in her now-fully-returned pidgin accent, and, though I had to try a little harder to understand what she was saying, I felt like she was speaking my language.

The Fiction of Old Friends

The Fiction of Old Friends

Driving south down I-95 on my way to Miami to visit an old friend not long ago, a feeling of trepidation began to overwhelm me. Though I was born, raised, and have spent more than seventy-five percent of my life in Florida, I'd never been to Miami. I'd never seen that part of Florida that most people from elsewhere picture as Florida: the red tile, Spanish-style houses; the fifties version post-modern architecture; the beaches full of the beautiful people; the neon; the low-riding muscle cars; and all the other stereotypes. But that wasn't what filled me with apprehension. Miami itself didn't scare me. Mark Scholl scared me.

Mark's an old college buddy of mine, one of those guys who I don't see too often now, so he resides in that part of my memory that I try to stay away from. I guess it's the by-product of a wild youth, but when I think of guys like Scholl and the shit we did, I smile and laugh, but it's not a nostalgic smile and laugh. It's a nervous reaction. It's that residual part of my psyche that still thinks, despite evidence and statute of limitations proving otherwise, that someone is going to throw me in jail for all that shit, sooner or later. And the dangerous thing about Scholl and me is our ability to push each other too far. There's always that next challenge, that next dare, that next ill-fated sprint that seems to stop just before going over the edge of something big. Mark's first wedding was a good example of that.

I trashed Mark's first wedding. Well, not the wedding. I missed the wedding. I missed the reception, too. It's a long story. Too much nervous dread to get into, but the gist of it is: Mark got married in St. Augustine, about two hours north of where I was living at the time. The wedding was kind of a sudden thing. I got the invitation on my answering machine on the afternoon of the wedding, and I only knew where Mark's hotel room was. So I packed up into a car with a gang of drunks and a bottle of whiskey that I'd intended to give as a wedding present.

We drank half of the whiskey on the way up to St. Augustine. I

couldn't find the wedding or the reception, so I spent the whole night drinking in St. Augustine bars with my gang of drunks. When the bars closed, we walked back to our car, which was parked in front of Scholl's honeymoon suite. We noticed that the light was still on in Scholl's hotel room, so we busted in with a half empty bottle of whiskey (half full for a guy like Scholl). Scholl's new bride was really angry about this. Scholl was just happy to see booze after the bars closed, so the gang of drunks, Scholl, and I left the room and walked down to the river to have a drink.

We stayed up for another couple of hours, hanging out alongside whatever river it is that runs through St. Augustine, drinking straight from the bottle, dancing to no music, howling at the moon, pissing off the sea wall, pissing off all the residents of Scholl's hotel, and racing at least three fifty-yard dashes. By the time Mark staggered back up to his honeymoon suite, it didn't matter if he was an optimist or a pessimist. That bottle was all the way empty.

Years later, after the divorce, Mark told me that his erstwhile wife wrote a poem about Mark stumbling into the honeymoon suite and asking her if it was all right for the rest of us to crash on the floor. She called it "Wash Your Dirty Feet Before You Get Into My Bed." Or something like that. I never read it, but I'm sure it was equally hilarious and sardonic. I loathed Mark's ex-wife, but I have to admit that she was a hell of a good poet.

She was also my ex-girlfriend before she was Scholl's anything, so you see how tangled this web is. So you see those nervous smiles, hear those apprehensive laughs.

As I drove down to meet with Scholl again recently, though, the whole wedding thing didn't worry me too much. That was a long time ago. Sometimes it seems like a whole other lifetime, like events that happened to someone else. Sometimes I know that it was all this lifetime and that the events didn't just happen. I caused them. This is especially clear to me every time I try to apologize again to Mark, but I can't do it without laughing. It's the same laugh that always seems to come up immediately before I get arrested or get my ass kicked. Mark neither arrests me nor kicks my ass. So that didn't worry me. The ability to push each other too far worried me. I took some precautions before leaving I-95. I put enough money in my shoe to get back home. I drove past all liquor and convenience stores, hating to be the kind of rude guest who shows up empty-handed, but preferring that to being the kind of guest who shows up inviting trouble.

The Fiction of Old Friends

It turned out to be good that I didn't invite trouble. Mark wouldn't have taken me up on the invitation if I had. Instead, we sat on his porch and drank Pabst and told stories. Not stories of the days of old, of the wild times, road trips, acid trips, forgotten friends, forgotten professors, and quarts of beer that we sold blood for. We talked about more recent shit, stories full of introspection and small revelations rather than saturated with booze and drugs. Mark talked a bit about his divorce.

It was around sunset at this time. A warm breeze blew through the porch. The high green grass and potted plants and vines in the nearby garden made it seem cooler. Mark's dogs ran underfoot and in and out of an open screen. I glanced alternately at termite shavings along the porch rail, at the light from the oil lamp, and at Mark's face as he talked about his ex-wife, Allison. Like I've said, she was also my ex-girlfriend, but barely. It's never been a bone of contention between Mark and me. Allison and I had only gone out on a few dates, and you can't really even call them dates. I took her once to sit on a friend's roof and drink tequila, then we hung out at a few bars a few times over a few weeks, and that was pretty much it. I wouldn't even remember who she was if it weren't for two things. First, she put an old friend of mine through four or five years of hell. Second, she told me something once that, for years, pissed me off every time I thought about it.

One time, when things were fresh between Allison and me, before I grew to loathe her, before she grew to feel the same way about me, we had one of those just-starting-to-get-to-know-each-other conversations about our pasts. Allison told me about being a young girl and going to the country club with her mom and dad. She said that her parents would take her there often. She would play on the playground with other kids or go swimming or do another of the thousand things to do at the country club. Her dad would sit at the country club bar and drink gin and tonics slowly. "Then," she said, "he would drive us all home. Can you believe that?"

Not seeing anything particularly strange about it, I said, "Yeah. I can believe that."

"But he'd been drinking all afternoon," she said.

Again, not seeing anything strange about that, I said, "Yeah, so?"

"So he drove us home drunk," she said. "Don't you think I should be scarred by that?"

My first thought was, are you fucking kidding me? My dad has driven me home when he's been drinking a bunch of times. That's how he and I got home from bars whenever we went out drinking together.

These are good memories for me. So when Allison said she should be scarred by them, my second thought was to get up, walk out of the house, go somewhere else, and find a new girl. Instead, I decided to try to understand this childhood scar. "Was your dad abusive when he drank?" I asked. "Did he hit you? Make fun of you? Abandon you?"

Noes all around. "I don't remember him acting any different when he drank," she said.

Being the sensitive kind of liberal arts student I was, I said, "I'm not really understanding where the scar comes from here."

"Well, he was drunk when he drove us home," Allison said. "He could've killed us."

I asked her if he'd had any close calls, even though I knew she'd say no. I got frustrated, but kept on prying, only to find out that she didn't feel lonely, had plenty of kids to play with, got tons of affection from her father, he even spoiled her, she admitted, and in general, even the weather was pleasant on those summer days. I got so mad that I said, "So what you're telling me is that you're just a spoiled little country club girl who's sad because her childhood was so idyllic that she can't cash in on the new trend of writing memoirs of an abused childhood. You're fucking pathetic."

At least I hope I said that. I probably didn't. I probably acted all sensitive in hopes of getting laid. But let's pretend I didn't. For all of us out there who don't have to dig into a country club sandbox to find childhood scars, let's pretend that I put her in her place.

I thought of this as Mark told me of the shambles of his marriage and divorce. I thought of all the bits and pieces of our shared past: of Kentucky thunderstorms; snowy north Georgia mountains; a smoky Panhandle bar after a day of driving; the time he sat in the front seat of an Oklahoma State Trooper's car, the trooper asking, "How well do you know this Sean Carswell?" I thought about Allison and her scarless subconscious and the scars she left on Scholl, and I wondered if I was even getting the story right, what with so many years passing, so little time spent thinking about it, with so much time spent pickling and frying my brain. I wondered if I had any of the details right about anything; if I could even remember what Allison looked like; if I knew this man sitting across the porch from me at all, this man who looked so much like a boy I thought I once knew. At the same time, I didn't want to tell all of those old stories just in case I had them wrong; in case the events I attribute to a wild weekend in Chicago really occurred one weeknight in Tallahassee; in case those brilliant friends of days gone by

were really just angry kids blind to the world; in case I'd been able to forget anything that I really wanted to forget; in case my mind had jumbled everything. I don't want the facts of my past. The facts aren't the point. They never were. They never are. Facts are just things we use to make our lies or misunderstandings more believable. I don't want that. I want my memories.

It was then that it occurred to me how much of our understanding about life and people and patterns of human behavior is really fiction. We take the events of our lives and condense them and reshape them and mold them into a story that eliminates details but adds meaning. We take the facts that we know about our friends, blend them with their personalities and come to understand them as characters rather than humans, just as I did driving down I-95 South. I assumed Mark to be a static character. Like Sal Paradise in *On the Road*, Mark should be the exact same Mark every time I choose to pick that book up. For that reason, I assumed that he'd try to push me into one more shot, one more joint, one more wild night. But as he sat on his back porch filling me in on all the episodes of the three years when we weren't in touch, I realized that the characters who are our friends are constantly being rewritten, growing, developing further with a mass of back story that never makes it into the draft that we get to read. When we are reacquainted with friends after a week or a year or a decade, we're presented with the new chapters, and we have to decide if we still like this book, if it's turning out the way we'd hoped it would, or if we should trade it back to the library for a new one. Regardless if the people we once knew have grown into different directions or not, regardless if we still like them or not, each and every one of our friends, our acquaintances, our strangers, and ourselves are too complex to really know through a few conversations, some beers, some shared experiences, so we condense, shape, and mold people into characters. By the same token, our life's experiences are too broad and convoluted to understand as a whole, so we choose to ignore most of the details, keep what we think is important, and condense, shape, and mold experiences into stories. That's what makes our true stories fiction and our fiction true. That's why details are unimportant. They can overwhelm us in our search for meaning.

That's what I thought about on that back porch in Coconut Grove when the sun set and the Pabst went down. Then, I wondered if maybe I'd just been writing fiction for so long that the line was only blurred

for me. But the events of the night made me think otherwise.

We ended up in a bar listening to a guy play guitar. When the room was fairly empty, he played blues-y songs and sounded like Tom Waits. When the room was crowded, he played old Motown songs and sounded like Michael Bolton. Mark's new wife (who, incidentally, is a huge improvement over Allison and a Filipina to boot) liked the musician, so we stayed and talked a lot during the Motown songs. Because it was an election year, we talked some about politics.

We differed on the presidential race and debated it for a while, both of us giving reasons that weren't really our reasons but reasons someone else had come up with and promulgated effectively and we came to agree with. Mark's arguments had no effect on my opinion, and my arguments had no effect on his because we'd both heard someone else espouse the same points of view at some other time. Out of nowhere, I asked Mark, "Have you ever read 'The Lottery' by Shirley Jackson?"

"Oh, yeah," Mark said. "That's a great story."

And it is. It's about a little farm community that has a lottery every year. Shirley Jackson sets it up as a nice, sweet town and a nice, sweet story. The townspeople are very traditional, and one of their traditions is the town lottery. Most of the people in the town believe that the lottery has some sort of unexplained but direct result on their crops, so everyone in town participates, and in the end, the winner of the lottery (in the story, it's a woman named Mrs. Hutchinson) stands in the middle of the town and everyone throws stones at her until she dies a gruesome death. It's an eerie warning about blind adherence to tradition, among other things.

"Think of this upcoming election as the lottery," I said. "Everyone's throwing the stones at poor Mrs. Hutchison. You're in this town, whether you want to be or not. You have a stone in your hand. Where are you going to throw it? Are you going to throw it at Mrs. Hutchison so that you don't waste your stone? Are you going to put it on the ground and walk away, choosing not to participate? Are you going to wing it at the guy who orchestrated the lottery? What are you going to do with that stone in your hand?"

I could see the lights flickering and flashing in Mark's head like a late afternoon thunderstorm. I could see him really, genuinely contemplating the election. Rereading "The Lottery" a few weeks prior to visiting Mark had had the same effect on me. It made me realize that

all the truths of the election were fiction, the facts were unimportant, and the fiction of "The Lottery" was true, so the story had some meaning.

The next morning, I had breakfast with Mark, his new bride, and their friend Betty. By way of introducing me to Betty, Mark said, "Sean and I spent most of our college days drinking on rooftops, taking crazy road trips, smoking grass..."

"The *On the Road* phase," Betty said, shaking her head knowingly.

I wanted to protest, to tell her it was no phase. I wasn't some Deadhead trying to recapture a lost time that never really was, following around a blind messiah in a desperate attempt for an enlightenment that would never come. I wasn't trying to live in a bubble, a dream world in the form of a novel. I wanted to explain and wondered how when Mark said, "No. It wasn't that. We were gassed up and ready to go before that novel came along."

And Mark was right. A book like that wasn't the engine that drove us. That's something I've always found hard to explain. Sure, I'm a huge fan of Jack Kerouac. Yes, I still read him. Yes, I still hold Kerouac up as one of the most important American authors. And I know it's become a cliché for writers in this day and age to hold him in high esteem, but fuck, I loved *On the Road*. I loved *The Subterranneans* and *Dharma Bums* and "October in the Railroad Earth" and *Big Sur* and *Mexico City Blues*. I have the album he recorded with Steve Allen. I still listen to it. Often. I can remember not only where I was when I read each of those books and what library or bookstore I got them from, I can remember what was written to the point of being able to quote long passages from the top of my head or straight from my heart. I know that being a writer and paying tribute to Kerouac is akin to being a pop punk band paying tribute to the Ramones, but I don't care. Truman Capote never inspired me. T. Coraghessan Boyle never made me think. Norman Mailer didn't give me an outline to modern rebellion. *On the Road* did all of those things for me. Still, *On the Road* wasn't the engine that drove us anywhere. It was, and is, more like a spark plug creating a steady flame, igniting gasoline to drive the pistons to rotate the axle and put us in motion, but it was always Mark or me or one of our other accomplices pushing down the gas pedal and steering.

Driving north on I-95 after a less than twenty-four hour visit to Miami, with money still in my wallet and in my shoe and the strange sensation of not having a hangover, I felt vindicated. Before going

down there, I'd been in kind of a funk, wondering what I was doing with my life, wondering why I spent so much time reading stories that never really happened, studying the effects of artificial events, staying up late most nights to hammer away at the lives of imagined people in fictional situations; why I lived and died and cared so much about these figments of my imagination. I wondered a lot why it had any importance to the world and whether I was justified to wallow in poverty so that I'd have time to make up stories for other people to read. Shouldn't I be spending more time on real events? Weren't there enough real people with real drama? Weren't real situations more vital? If I must write, shouldn't I be writing about those real people and real situations? Maybe dedicating my time to investigative journalism, to exposing the ignored problems in our society?

Hanging out with an old friend after recently finishing the rough draft of a second novel, though, made me see fiction and non-fiction in a larger construct. It made me realize that the events of the world are so monumental and the simple things like experiences and people are too complex to understand, so we develop these artificial constructs like stories and characters just so that we can make some sense of the chaos. Understanding this and thinking about the stories of my past, the stories I've told here about the wedding and Allison's scars, I realized that these are true stories in the sense that they really happened to the best of my memory, but that they're no more true than the stories I just wrote in my novel, because they are both artificial constructs developed to help people better make sense of life's complexities. This realization carried through to my conversation with Mark about politics, because all the political views that reach you through the great media filter are basically fiction, and the fiction of "The Lottery" has more truth to it than anything Fox News has ever said. By the same token, Sal Paradise from *On the Road* is more real to me than Ronald Reagan ever was because, even though neither of them exist in the same world as me, at least Sal Paradise has some relevance to my world.

So, I felt pretty good about all the time I spent writing and reading fiction and publishing fiction because, in the end, great nonfiction authors like Emma Goldman or Ben Bagdikian can give us all the evidence we need to support our opinions. They may even help us change our minds. But writers of fiction like Jack Kerouac and Shirley Jackson change the way we think about life in general.

My life was finally making a little bit of sense.

About the Author

Sean Carswell is a former carpenter, house-painter, dishwasher, pizza delivery boy, college professor, waiter, bartender, warehouse clerk, junior high school teacher, and grunt in a various assortment of construction jobs. Currently, he ekes out a living as a co-founder/editor of *Razorcake Magazine*.

About the Artist

Tom Wrenn has studied art at the College of Charleston, where he was Outstanding Senior Artist in 1993, and at the Art Institute of Atlanta. He currently holds degrees from both of those places. He works as a freelance artist sometimes and a line cook other times. Sometimes, he doesn't work at all. His artwork has appeared in *Razorcake*, on the cover of *Archeology of Bones*, and in various other places.

Also available from Gorsky Press

DRINKS FOR THE LITTLE GUY by Sean Carswell
paperback - 279 pgs. - $10.00 ppd.

After a visit from a stranger in a flowered shirt, a young carpenter disappears from his coastal Florida hometown. Now his friends are left to examine his life and their own to solve the mystery of the stranger and the disappearance in this tragically funny novel about America's working class.

DEAR MR. MACKIN... by Rev. Richard J. Mackin
paperback - 200 pgs. - $10.00 ppd.

For years, Rich Mackin has charmed the underground zine culture with his "consumer defense corporate poetry." What started as a simple letter asking M&M's what their name means has evolved into haikus for Q-tips, limericks for Frito-Lay, a war with Lever 2000, hundreds of hilarious letters to corporations, fourteen self-published books, and columns in *Suburban Voice*, *Flipside*, and *Razorcake*. *Dear Mr. Mackin...* selects Mackin's favorite letters, poems, columns, and assorted mania.

THE OTHER CANYON by Patricia Geary
paperback - 130 pgs. - $10.00 ppd.

Carla is a "sensitive"-a woman vulnerable to the vibrations and energies of metal that most people can't feel. When she comes into possession of a silver necklace that was probably stolen from the Navajo reservation, Carla cannot ignore the signs that compel her to return the necklace. With her ever-indulgent best friend Lucy, Carla embarks on a journey to Canyon de Chelly to return the necklace to its rightful place.

Along the way, Carla and Lucy encounter a bizarre cast of cowboys, Navajos, Hopis, and German experimental filmmakers. Carla must discover new rules for surviving, and what transpires becomes an odyssey that forever blurs the lines between imagination and reality.

RAZORCAKE MAGAZINE
bi-monthly music magazine - $3.00

Razorcake is produced by and includes most of these Gorsky Press affiliated rogues. Each issue features regular columns by both Sean Carswell and Rich Mackin. You can learn more about it and read all kinds of cool stuff at **www.razorcake.com.**

ALL PRICES INCLUDE POSTAGE
send cash, money orders, or checks (made payable to Gorsky Press) to:
Gorsky Press
PO Box 320504
Cocoa Beach, FL 32932
or visit:
www.gorskypress.com